WE ARE HEROINES

GW00468161

We Are Heroines

Sejuti Mansur

Published by Sejuti Mansur, 2021.

While every precaution has been taken in the preparation of this book, the publisher assumes no responsibility for errors or omissions, or for damages resulting from the use of the information contained herein.

WE ARE HEROINES

First edition. August 2, 2021.

ISBN: 979-8201797935

Written by Sejuti Mansur.

I don't give a damn what you were wearing
I don't give a damn how much you drank
I don't give a damn if you danced with him earlier in the evening
If you texted him first or were the one to go back to his place.
People may continue to come up with reasons "why it happened"
But the truth is, I don't give a damn.

But I do give a damn how you're doing
I give a damn about you being okay
I give a damn if you're being blamed for the hurt you were handed
If you're being made to believe you're deserving of pain.
The only reason I am standing here is because people gave a damn about my well-being
Even when I did not.
They reminded me that I carry light and I deserve to be loved. Even when I forgot.
They gave a damn. That's why I am who I am today.
So here's the takeaway. When we step up for survivors when we stop sealing them off in shame
When we quit interrogating them with stupid questions
Look what happens.
Books are written, laws are changed, We remember we were born to create
To not only survive, but look hot and celebrate.
Tonight you must come away knowing
That I will always, always give a damn about you
The way you gave a damn about me.
- Chanel Miller

FEMINISM: A CONCEPT deeply ingrained in history—so simple, yet so controversial. It has broken structural barriers within society, empowered young women to stand up to their abusers and shaken patriarchal systems deep in their cores. Nonetheless, feminist rhetoric continues to incite rage and offend; South Asia is not immune to this.

Despite the taboo nature of feminism in South-Asian culture, the time has come for its society to understand that women are not merely our future wives, child-bearers or support systems.

Women are our future CEOs, presidents and leaders.

Feminism may appear more prominent in Western culture; however, it has been the scarlet heart of Bangladeshi history. The desire for radical freedom was ignited in the aftermath of the 1971 Liberation War, accompanied by a rising tide of women's empowerment. There was a real dedication to political commitment enacting societal change, and the taste for revolution zealously became infectious. More than ever, there was a loud battle cry for feminism.

The beauty of feminism is the absolute simplicity of its ambition. It is the fight for equal rights between genders, harmonising women earning the deserved opportunity to construct personal identity. Consequently, it combines both the theory of freedom and the art of exercising that freedom: an ideal setting in reality. Regardless, there is a clear division in differing cultural, economic, and political spheres on women's value.

It is not a myth that South-Asian culture has many obstacles to aspiring to the feminist ideal. The scope of the women's movement is more extensive in this context than any other theoretical framework. The "ideal woman" archetype constructed in cultural ideologies has manifested into women's obedience. It is a woman who "submits to all manners of misfortune in silence". The values of innocence and modesty uphold. The archetype has determined people's way of thinking and shapes society.

It brings forth socio-economic policies based on formal aspects of living, including food, security and housing, which should be normalised across all genders. Several South-Asian countries share the same conflicts, such as the collective experience of patriarchies overshadowing the women's rights movement's progressive efforts.

As a result, many disregard the blatant issues in gender equality because the state plays a crucial role in addressing gender issues. However, the stubbornness of patriarchal views has hindered real liberal success.

The patriarchy's obstinacy may emotionally burden the women's movement, but the ferocity of Bangladeshi women should not be underestimated. We have a long history of women becoming the masters of their fields and smashing through hurdles implemented by patriarchal ideals. Our country was founded on euphoric independence, with the first Prime Minister, Sheikh Mujibur Rahman declaring the "four pillars" of Bangladeshi: nationalism, secularism, socialism and democracy. Such supreme ambition has rippled through generations of women; from Begum Rokeya to Zaiba Tahyya, it is no wonder that young women are pursuing an independent life—there is a strong heritage to inherit.

This book is a tribute and celebration of everything these brave Bangladeshi women have done for us, their daughters.

A tribute and celebration which is long overdue.

THE BIRTH OF INDEPENDENCE

Bangladeshi society can be easily categorised as the 'classic patriarchy' whereby expectations of life patterns have resulted from a strong male lineage. In classic patriarchy, the social structures are personified by restrictive behavioural codes for women and are institutionalised in every measure that affects society. As a result, it is common for institutions to have rigid gender separation with specific familiar structures.

Sylvia Walby describes the central element of the patriarchy as "systematically structured gender inequality"[1]. Furthermore, one only needs to turn to the household structure to see such attitudes executed. Women have familiarised and conditioned themselves into the caretakers of the household. These roles facilitate control and discipline the women into adhering to specific modesty customs. The dominant ideology limits family honour to feminine virtue. The men are entrusted with safeguarding this honour, through control of the household and its members.

Traditionally, household resources were pooled with the masculine figures having a monopoly over the women's labour, sexuality and mobility outside the home. Only a tiny percentage of households can be described as female-led households. Often, these circumstances occur "through widowhood, divorce or desertion by husbands, long-term migration of male members and men's loss of employment capacity." [2]

Nevertheless, this does not guarantee independence or protection. If we continue to abide by traditional customs, certain women will always be vulnerable to no protection. For instance, infertile women, unmarried mothers or divorcees are not protected by societal structures because there is no dependence on men. Therefore, feminist scholars have argued that this is not necessarily a sign of voluntary independence, but it is seen as a "continued social abandonment of women."[3]

In Bangladesh, it is common for men to dominate women through private and public spheres of patriarchy; with the former based on men controlling women individually within the household, whereas the latter is the expropriation of women collectively. In both spheres, men have deemed themselves responsible for overseeing women's behaviour to uphold community honour. If women deviate from appropriate roles, it is believed punishment is deserved. Hence, violence against women. Socially gendered norms uphold the entrenched perceptions of masculinity.

Unfortunately, the system caters patriarchal interests. A historical preference for men within the family has led to detrimental effects. In society, there are visible manifestations of this preference as financial resources are passed down to sons. In consequence, these dominant patriarchal attitudes can be strategically used by men to secure power and authority. [4] Therefore, it is common for female-led households to have less control over resources, thus leading to a greater dependence on wage incomes and often with the women struggling to defend their right to their property.

There is a wide disparity between male and female representation in the public sphere. The strong presence of patriarchy has led to the exclusion of women from economic and political

power. In the political sphere, men tend to monopolise political power. In a capitalist society, male superiority is maintained through job segregation by sex.

As a result of this male domination of political institutions and flawed judicial institutions, there is weaker legal protection of women in all spheres of life. [5] We must do more to address sexual and gender harassment in the public sphere, as there is a weak legal framework for protection.

There are great hindrances to women in employment, including a toxic work environment, work-life conflict and sexual harassment.

[6] Consequently, this is a real detriment, as women's entrepreneurship is vital for the country's economic development. In 2019 alone, Karmojibi Nari asserted that 12.4% of garment workers reported sexual harassment in the workplace, but we can ascertain that the percentage is higher because women live in fear of speaking out.[7] The conceptual separation between men and women has manifested in severe restrictions on women's movement within the labour market.

Bangladesh's female labour force participation rate has risen, but there are hindrances to women excelling in positions of power in our industries. Consequently, this enforces the lack of female employment or lack of equal respect in the labour market. As a result, women remain dependent on men; thus, they are compelled to perform domestic responsibilities because there is no other alternative.

The notion of the patriarchy has been a longstanding presence in history. The word itself is an ancient Greek term, meaning "the rule of the father."[8] Gerda Lerner, a principal founder in the academic field of women's history, argued that the patriarchy is a historical creation by both men and women; a patriarchal family is the necessary result of its nature.

Likewise, feminist writer Kate Millett believed that family is the leading institution of the patriarchy. A person's worldview tends to stem from their upbringing, and the family can encourage its members to conform to the sexually differentiated roles which maintain a woman's inferior position. A demonstration of this is blatantly evident in Bangladeshi families, where tradition dictates that the father is the breadwinner, while the mother is the caretaker.

These ideas transcend into the public dimension. As Millett wrote, "the military, industry, technology, universities, science, political office, and finance—in short, every avenue of power within the society, including the coercive force of the police, is entirely in male hands."[9]

Many other feminists have advocated for this point: Maria Mies rightfully argues that male dominance is not only seen in the "rule of fathers,", but in the rule of husbands, male bosses and the ruling men of society and politics. Male dominance is secured in material resources, and therefore in a capitalist society, men will always have the upper hand over women. The patriarchy is solidified on a financial basis in Bangladesh. For instance, men tend to have absolute control over means of production — namely, land. Therefore, decision-makers go unchallenged over the distribution of power within the household.

Women face diverse challenges in the patriarchal dominance in Bangladesh, as familial, political and religious systems support the supremacy, men determine their families' economic mobility. In the same manner, Christine Delphy views the patriarchy as a system of oppression within the home: in her words, a "domestic mode of production." In an interesting take, she believes marriage to be an institution in which her husband appropriates a woman's unpaid work.[10]

Women are perceptive to vulnerability through traditional marriage, as the customs of patrilocal marriage removes married women from their birth family and places her in her husband's locality. The logic is evident in the lack of regard for the emotional and physical burdens a wife must endure in taking care of the home with no sense of gratitude in return—it is expected of them.

Careless disregard for a woman's emotional wellbeing has transformed into violent customs. A historical instance is a dowry: a bride's family's price was required to pay the groom's to secure the marriage. In addition to this, evidence has suggested that women do not receive a substantial dowry upon marriage. Therefore women are not endowed with money or property. As a result, there is little opportunity for independence in society. The act of dowries is now outlawed but does not mean that the custom has been extinguished.

Dowries have led to violence against women, and more shocking, death in some instances.

Mies points out that they are a source of wealth accumulated not using the man's work, but by "extraction, blackmail and direct violence."[11] Violence against women is extended control over women, as independent women are perceived as threats. These actions have been encouraged by the upholding of male entitlement; social institutions reinforce such benefit. Hence, the personal effect of the patriarchy is enmeshed with the political and the public sectors.

A more harrowing matter is child marriage, which legislation has banned since the 1920s; yet it seems that very little attention is paid towards this rule. It is prohibited in common law, but customary laws accept it as the norm. A new provision inserted into the legislation lowers the legal age under exceptional circumstances with the parents and court's consent. Aside from the worrying development, there are no safeguards about the unique circumstances. Therefore, the child is not protected. It is estimated that over 700 million children are married before the age of eighteen in a global aspect[12].

As Bangladesh is a mostly rural country, child marriage practice remains prevalent in rural areas and urban slums. Families often do not have the financial means to care for all of their children. Security is at the heart of forced child marriages. Without dedication to rural women's economic and social development, the nation cannot progress positively. Usually, child marriages' motivation may be connecting to financially abundant families, creating alliances within the community or obtaining financial resources. Namely, land. Thus, their daughters' forced marriages are deemed a necessary sacrifice. By reforming the progressive legislation, Bangladesh has created severe hindrances in child protection.

Child marriage threatens every aspect of a young girl's livelihood: their education, mobility, health and safety. It is an incredibly dehumanising experience, as children often feel treated as

commodities. Child marriages can negatively affect a woman's future, as they are pressured to end their education early for household duties.

It is common for young brides to experience high fertility rates and spend more time childbearing. Thus, there is no time even to consider a life outside the familial responsibilities. A renowned non-governmental organisation, Plan International stopped 2000 child marriages between 2013 - 2016[13]. It was the joint effort of state authorities, local communities and the families. The joint intervention has led to a decrease in child marriages, but the reduction is not sufficient. The lack of support prevents the child from becoming active agents of change.

It would be beneficial to both spouses for the underaged wife to delay childbirth and focus upon generating additional income. Therefore, cultivating her independence and strengthening the economic foundation for the family. Thus, opening new avenues for progressive opportunities for both spouses. If society were to encourage the elevation of a wives' status, it would counter stigma in delaying childbirth.

Nevertheless, the tradition to join her husband's household leads to the loss of autonomy as she is not within her own home, so her status is substantially reduced to that of a bonded labourer. A study recorded in Bangladeshi villages concluded that 60% of women endured physical abuse[14] in marriages where there was a power imbalance where financial resources were concerned. In situations of discriminatory cultural dynamics, there is severe physical and psychological abuse in child marriages.

There is an underlying fear that underaged wives become "spoiled" by the outside community and new experiences. Therefore, society dictates married wives be confined to their households within the union. Wives are perceived to exist for marital obligations only.

Pregnancy amongst underaged girls is astronomically high, at 66%.[15] It opens the child up to severe vulnerability because if her partner is abusive, from a young age, the child bride accepts that violence against women is the social norm. The benefits of delaying childbirth are well known, but the stigmas around infertility interfere with the girls' ability to delay childbearing. The obligations of childbearing and domestic roles do not supersede the need for progressive expansion.

Our ideologies have fueled the customs of unfair marriage, as characterised by oppressive patriarchal social structures. Thus, endangering the livelihoods of innocent children. Child brides tend to be much younger than their husbands; this introduces inequality within the marriage through an imbalance of power.

There is no natural progression from girlhood to adulthood, as girls are forced to take on responsibilities that they may not be mentally apt to do. It places girls in an unstable mindset. On top of this, underage girls are not matured physically for the consummation of the marriage. Therefore, there are severe consequences for her physical and emotional health.

The couples tend to have a significant age difference; this cultivates heavy dependency on the husband and restricts moral agency. The man gains social status from childbirth. He is respected as a responsible breadwinner and a family man. Such knowledge of these benefits places more significant pressure upon the husband to produce offspring imminently. In such power imbalances, the young wives are not engaged in family planning. The lack of knowledge of contraceptives in a male-dominated dynamic severely limits the control over pregnancies.

The stigmas on infertility yield a powerful influence over a couples' lifestyle choices. Therefore, there is a real drive to prove their ability in producing offspring in the early stages of the pregnancy. Despite the fact, an underaged girl's body has not matured for birth. Additionally,

if her husband is considerably older, it increases the girl's likelihood of being left a widow. Consequently, underaged girls are at a greater risk of raising children on their own, or they remarry and must produce offspring all over again.

As Bangladesh is constructed in a strictly patriarchal society, being without a husband can render women vulnerable to community abuse. Even if an underaged wife were to gain reproductive services, they are still subject to hostile providers and a lack of financial access to health services. Nevertheless, society has not considered the severe medical and economic burden that early childbirth may have. It is common for early childbirths to require costly emergency services, and the financial resources for such medical procedures are not always guaranteed. If the mother is not fully developed, the medical risks are endless. For instance, she is likely to suffer from haemorrhaging, sepsis, pre-eclampsia and many more. Therefore, it is illogical to pressure couples into early childbirths, but society expects us to do so.

Jessica Schiffman noted that women tended to submit to traditional norms. The submission was from the relentless emphasis that failure to exist with "an ill-defined sphere of safety" meant they would be "held responsible for whatever happens to them."[16] In regards to efforts to delay childbirth, underaged wives are open to many forms of suspicions. These suspicions can change from extra-marital relationships to attempting to undermine the power positions within the marital family. Often, this leads to underaged wives suffering abuse from her fellow in-laws, and she is expected to endure it.

Contemporary feminist politics was influenced heavily by these interactions as the broader social, economic, and political changes. Bangladesh has impacted the way that feminist activism has taken root and transformed over the years. The legal minimum age of marriages is eighteen, but the enforcement of this law is horrifically weak. Studies have concluded that the actual age is fifteen[17] and these girls are producing offspring before the legal age.

The Liberation War highlighted that women were not inferior to their male counterparts. The fact of the matter is that there would have been no victory without our heroines. Women were integral in the struggle through individual action and women-driven organisations, factions affiliated with the main political party, and women's rights campaigners.

These efforts did not cease to exist in the aftermath, as demonstrated by the many groups born out of the Liberation War: Bangladesh Mahila Parishad, Naripokkho, and Women for Women. As women struggled to find a voice and space within the communities, they recognised that the struggle for recognition was real. The grounds may change on the way everyone speaks about women's issues, but the political need for women to fight and organise is needed more than ever.

Feminist organisations differ from each other in terms of structure, location and orientation. Consequently, this is incredibly beneficial as some may be small grassroots groups directly empowering women in rural villages, or national operations with a more significant presence in current affairs. For instance, Bangladesh Mahila Parishad and Naripokkho focused on formulating agendas and activism through networks. On the other hand, Women for Women are a research enterprise, engaged in the production of knowledge; they pursued the strategy of lobbying and networking in their "activism."

Furthermore, there is a difference in prioritisation, as exemplified by Bangladesh Mahila Parishad, the oldest women's organisation established in 1970, being labelled as belonging to the "liberal school" of feminist discourse. Conversely, Naripokkho was known for continually challenging women's present viewpoint and reformulated the notion of violence against women, their body and sexuality.

It is an organisation which outwardly challenged religion at different points in time. It is possible to say that Naripokkho was the more radical of the two. Traditionally, a woman's role in society was

strictly limited to the private sphere; hence, it was encouraging to see women liberally entering all spaces.

The bravery of women's rights groups should not be dismissed as the very existence tempts challenges. They face difficulties maintaining sustainability with the inability to attract and retain young activists; the disheartening decrease in international funding; the ferocious conservative backlash against the movement; and the rise of extremism diminishing the feminist voices.

Due to this backlash that feminist organisations are sometimes forced to modify their aims to accommodate existing power structures. It is a common belief that there is a deep opposition between the state and feminist non-governmental organisations. The debate on whether NGOs are beneficial to national developments tends to swing between extremes.

On the one hand, NGOs are perceived to be embodying the best of Bangladeshi society with principles inherited from the Liberations War. On the other hand, there are accusations of NGOs operating as functions against the national interest. As the "the new right" rises, there is a distrust of NGOs, they are seen as a "threat to the public interest" with encroachment on liberty.

There is a growing cynicism that NGOs are motivated by market competition with an emphasis on profit[18]. The most significant arguments against NGOs is the practice of "charging high-interest rates, inappropriate selection criteria for target groups, and inflexible product design and delivery."[19] Whether that be true or false, it reflects NGOs' struggles to establish themselves as a legitimate voice among the Bangladeshi people.

While there appears to be mutual interest between the state and NGOs in delivering a "thriving civil society"[20] - gender inequalities are still persistent. Differences in nutritional and health status exemplify such disparities, the gender wage gap, the smaller number of

women in political and economic leadership positions, and the high levels of violence experienced by women in both the home and public sphere—both physical and psychological.

The increased participation of women has elevated women's status in society because women can contribute economically to their households. Evolution in women's empowerment and economic gain has significantly influenced the decline in violence against women.[21] , therefore as long as gender inequalities persist - so shall danger for women.

The empowerment has been achieved by embracing more agency and opportunities for women. Through leadership and societal status, the individual and collective agency has given women the ability to imagine a better future. Women's empowerment is a complicated issue and cannot be solved merely by rhetoric and empty promises. We must continue to advance individual and collective agency for all women.

Objectively, it would appear that the resistance towards gender equality stems from society, rather than the state. Throughout its history, the country seems to have taken positive steps to enforce feminism, as reflected in Bangladesh's Constitution. It guarantees equal participation in the public sphere, with Article 27 stating "all citizens are equal before the law and are entitled to equal protection of the law."

However, behind closed doors and within the private sphere, women are not regarded as equal to their male peers. The Constitution does not extend beyond this. It is not a strong basis to determine the extent of the state's commitment. There is little protection for women in the respective field as the Constitution of Bangladesh solely considers the public, as demonstrated by Article 28 (2): "women shall have equal rights with men in all spheres of the State and public life."

Women are vulnerable to limitations in their private lives as showcased by women's rights within marriage and their rights to divorce. The strict elements of religion have tainted society and limited women to strive for gender equality, which contradicts the

Constitution. Article 28 explicitly states that "the State shall not discriminate against any citizen on grounds only of religion, race caste, sex or place of birth."

Despite the obstacles, there have been tremendous efforts by feminists to improve women's health and increase opportunities for education participation, economic expertise and executive presence. From a broader perspective, women's empowerment is necessary for building just societies.

If we do not elevate both genres to an equal level, we shall not achieve high targets for development, sustainability or human rights. Women, men, families and communities all shall suffer. Therefore, we must commend Bangladesh, where praise is due. The efforts to extend access to primary and secondary education have succeeded in the reduction of gender disparities.

In the same vein, feminist NGOs deliver economic and welfare benefits to the disadvantaged. Women have the freedom to remain unmarried, with extended investment in higher education. These are clear signs of more excellent agency through education, and it allows both genders to see the detrimental effects of no education and early marriages. Nevertheless, there are clear signs of sex segregation in Bangladesh's educational system.

Due to the gendered conditioning within society, men gravitate towards STEM degrees, and women do not. The state must stay committed to improving access to education for both genders, eliminating gender gaps within education. These practices are essential strategies for ending travesties, such as the norm of child marriages. As a consequence, both genders can work together to push beyond traditional gender roles. Indeed, this is where the true beauty of the feminist movement shines.

As a consequence, Bangladesh has been ranked highly in UNDP's Human Development Index. Given the country's age, the pace of change and achievement is remarkable, particularly as Bangladeshi

women tend to have a lower starting point than women in other South-Asian countries. Nevertheless, there is criticism on the subject of state education.

Bangladesh has been prosperous in eradicating gender parity in theory, but the school have remained gendered institutions intending to socialise girls into gender-appropriate behaviour. Consequently, data demonstrate that girls are losing through growing gender disparities in primary and secondary school education. Thus, leading to secondary school dropouts.[22]

It is acknowledged that gender development is key to bettering the lives of all human beings. The International Labour Organisation publicly declared that "the promotion of women's participation in economic activity, including the management and decision-making levels, is not simply a question of equity, but also one of a necessity for viable and sustainable national development."[23] From a sociological view, women must be involved in economic activities or struggle to achieve our national targets. The empowerment of women is in the interests of a better society.

Equality is not an elitist dream; it is imperative to politics. It requires a complete reawakening of opinions, in which women and men do not limit their decisions by gender norms. Consequently, this is so much greater than merely ensuring women have access to equal rights and opportunities - it is the need to create a new philosophy where all humans are active agents of change and believe that equality between the sexes is essential to life.

The policies that centre on women's economic autonomy and rights shall conflict with patriarchal interests. Therefore, it is inevitable that progressive policies shall be met with resistance. Thus, the state must fully support the women's movement for a successful transition into a new age.

Fundamentally, hope lies in Bangladeshi women's hands, who have demonstrated leadership in demanding their rights and pioneering

social change. There has been increasing concern from women activists about endangering human development through patriarchal means. Therefore, the state's relentless pressure to listen to feminist demands has led to an active discussion on women's rights. The integration of gender equality has been placed into the national development agenda, and Bangladesh's future is very bright.

THE BIRTH OF THE SISTERHOOD

T he greatest battle of feminism is conquering the subject of sexual
 assault.

Sexual violence is a gender-specific violation of human rights. It
continues to subordinate women and uphold patriarchal structures
through society. It is not confined to any particular system, but
prevalent in every society in every corner of the world.

It is one of the most exceptional taboo topics in South-Asian
culture. Studies have demonstrated that Bangladeshi women suffer a
"high prevalence of sexual violence in their lifetime."[24]
Unfortunately, the tradition of purity and modesty has hindered
progression in Bangladesh due to the notion that a woman must always
remain honourable. Not for themselves, but for society–a society that
does not know the woman, a community that has never seen the
struggles the woman has endured, but a culture that feels entitled to
comment.

Sexual assault is a poisonous parasite that has infected every inch of
the Earth. Bangladesh has improved its approach to women's issues, but
the country exhibits shameful handling of sexual assault and its victims.

Despite the many legal instruments to combat sexual violence,
there is a failure to enforce against sexual violence. There is a lack of
awareness and weak enforcement. There is no confidence in lawsuits
because the law has not been revised thoroughly to suit modern times.
Therefore, laws are limited in their effectiveness. There is no robust
implementation. Therefore the court is not seen as a safe place for
women.

Sexual violence is used by men in "every stratum of society" with
the absolute "desire to dominate and control women through violence".
It not only derives from gender inequality but solidifies a man's power
in maintaining fear in a woman. Sadly, Bangladesh's relationship with
sexual violence dates back through history. Notably, the Liberation
War.

In the more valiant view of the Liberation War, stories were told of brave women taking up arms and joining the underground resistance. Women were moulded into symbols of modernisation and liberation. These women were given extraordinary significance in the historical narratives, as they were epitomised as the "patriotic motherhood" for allowing their sons and husbands to fight. However, these respectable and self-sacrificial imagery does not tell the whole truth.

The Liberation War witnessed some of the greatest atrocities to humanity; namely, the calculated killing and mass rape of women. Amongst 30 million fatalities, it is generally agreed that 200,000 to 400,000 women were raped. In reality, it can be assumed that this number is an apparent underestimation to the situation's gravity. We must speak of this, as the past retelling shall allow survivors to recognise their experiences. The gravity of the situation must be known, so we may create public awareness and move beyond the legacy of trauma.

It was crystal clear from the beginning that ethnic cleansing was at the heart of the Pakistani military's war. It was a terror tactic, intending to be a national victory. By defiling the honour of Bangladeshi women, it achieved the terrorisation of enemy territory. The Martial Law Administrator of East Pakistan made it known to the military:

"We are in enemy territory...we should change the race of the land."

They severely underestimated the Bangladeshi people's power with the incorrect notion that they were weak and powerless. Rape became a military and political tool to suppress the agency of a newly emerging nation. It should surprise no one that this was the intended effect, as sexual assault is the ultimate war weapon. Rape is used prominently in the battle to dehumanise female citizens. It is a conscious form of intimidation. In Brownmiller's eyes, rape is used to kept women in a constant state of fear.[25] Women are always the victims, subjected to silence under the glare of the public scrutiny.

This chapter will focus less on the actual act of military rape and rather the treatment of raped women after the war as there is a silence of women's voices in the collective memory. Therefore, women's experiences have been erased from the historical context behind gendered violence.

When abuse occurs, it is considered a profound offence against the individual and the community; the community believes her honour is lost. It disrupted the societal role of women, thus disrupting the symbolic integrity of Bangladeshi communities. As a result, raped women are dejected and ostracised by their husbands, families, and entire communities. People rejoice in hearing the stories of male heroes and their glorious victories. We pride ourselves on sacrifices but do not wish to hear about the sacrifices of our women.

Rape is the most common form of violence against women in Bangladesh, and the practice of rape is an inherently linked phenomenon to victim-blaming. The act itself is not motivated solely by sex per se, but by the need for power and domination. In the eyes of society, it rids a woman of sacredness. The failure to hold perpetrators accountable leads to a normalisation of male aggression.

It is a real shame to admit that Bangladesh is guilty of this. Rape is riddled with stigma in Bangladeshi culture, and it is a common theme for women to not report sexual assault, in fear of the consequences against them. The legal process tends to be time-consuming, and women are discouraged from taking legal action and fighting for their rights in court. Not only this, but women are subjected to negligence by the police, courts and society.

Clementine Ford described "rape culture" as a social system, which slowly normalised rape and sexual assault through the bombardment of imagery and social attitudes[26]. It is a culture that excuses or minimises rape; therefore, a man's truth prioritises a woman. The unsupportive beliefs and behaviours go unchallenged. The lack of evidence had grave implications for war crime tribunals; thus, many soldiers were not held

accountable for their crimes. Even more so, Bangladesh was not ready to confront such a heavy burden, despite every woman's valiant efforts in the war.

Throughout history, Bangladeshi women have been determined to have their voices heard. However, if the compassionate presence does not fairly represent state control and leadership, decisions made for women's benefit will not truly reflect the opinions and struggles of women. One only needs to look at the aftermath of Operation Searchlight, the mass military rape of Bangladeshi women, which began a wave of sexual assault and terror.

The heavily "masculine" presence in Bangladesh' state shifted the responsibility of treating rape victims to social workers and medical practitioners. The traumatic memories were suppressed into intense silence. All components of society discouraged victims' from speaking their truth. There was an influential paternal role on behalf of the Bangladeshi state, who placed substantial pressure on women to have abortions.

Dr Geoffrey Davis, a well-known practitioner, travelled to Bangladesh to assist with the aftermath of the war and believed that approximately 95% of wartime pregnancies were terminated in the Dhaka-based centres alone. In the devaluation of the victims' experiences, women were subjected to coerced abortions, thus not allowing them to claim agency. Therefore, there was no space to reconcile and heal from the tragedies of the war.

A rough estimation appears that centres performed more than 100 abortions during the first month of residence in the Dhaka rehabilitation centres, with 2500 in total. In his eyes, the state were guilty of providing the wrong information concerning the number of women subjected to rape in the Liberation War. To him, "the blame for the loss of honour" fell not upon the rapist, but on the raped." However, the state at the time should not be painted as the enemy.

In reality, they could not comprehend the sizable magnitude due to the severe lack of case documentation. Victims were afraid to come forward, paired with the horrifying fact that many victims were young girls. Nevertheless, by not speaking the truth to the public, Bangladesh has not made peace with its turbulent past.

Tragically, wartime abortions were never given the official status it needed to be delivered, nor were they treated respectfully. For a long time, there was a deafening silence that shrouded the whole affair of mass-scale abortions. When abortion was not widely available in Europe or America, the introduction of abortion in Bangladesh was unprecedented in global history. For some, these administrative decisions showed the Bangladeshi state to be progressive in its time. For others, the policies reflected the awakening "modernity" of the independent nation"[27]. In hindsight, given the cultural viewpoint, abortion seemed to be the only necessary option.

Rehabilitation focused on restoring purity and honour. Maleka Khan, the director of Bangladesh Central Women's Rehabilitation Centre, emphasised reinstatement into the family and society. She remarked that "we did not know what else to do. The women had to be re-established in their families and homes...how else could we have helped them?". For Ayesha Khan, the introduction of abortion and adoption was necessary to "protect women from the pressure of motherhood" and allow a less painful retransition into society".

It is easy to fall into the trap of treating historical events with a modern viewpoint; given the time, it is understandable that the Bangladeshi people reacted to their abilities best. Nonetheless, the attitude whereby family honour reigns supreme has continued, with the shame of sexual assault still carried to the present day.

The handling of this ordeal has drawn mixed emotions. For instance, the intentions of the Bangladeshi state had been good-natured. From the moment Bangladesh liberated itself, it projected an image of independence and modernisation. A state

committed to equality and justice. In reality, the country appears to be placed in a conflicted position. The conception of "Birangona" demonstrates this. As the state attempted to reinstate women into society, it succeeded in the "othering" of raped women via the marriage of rehabilitation. The pressure to hide the truth was prevalent, and therefore society was torn in different directions.

As the victim did not have the confidence to make their experiences known, the public remained ignorant of their stories. There was little knowledge of the survivors, and therefore, communities could not come together in humanity and elevate these women. The motivations behind the birth of the "birangona" were well-founded, as the purposes were to recognise and rehabilitate these women painlessly into society; nevertheless, the outcome itself was counterproductive. The denial of the truth led to the perception of the "birangona" being used to ostracise women.

The notion of the "birangona" was introduced shortly after the war. In late 1971, a Bangladeshi photographer Naibuddin Ahmed published a photograph of a woman raped by the Pakistani Army. The photo depicts a dishevelled woman with her fists crossed covering her face. The picture reached international acclaim because the world was introduced to the Bangladeshi war and more importantly - rape as a war weapon. The numbness in the photograph attributes to the raped women being seen as weak and voiceless. The photograph led to emotive responses, as the women's suffering was felt on a collective front.

Nevertheless, for many of the women, the silence was the only available option. The Liberation War's aftermath was not so simple, as it demonstrated the true effects of genocidal violence. The national consensus to erase and shun led survivors to erasing and silencing themselves. For some victims, silence is the only way to survive the consequences.

Sheikh Mujibur Rahman initially created the label to celebrate the female victims of military rape; 'birangona' was connotated initially with the idea of 'heroines'. Sheikh Mujibur Rahman had publicly called the Birangona women his daughters and believed in welcoming these women home with unconditional support. However, the meaning of the word soon became warped–'birangona' became a shameful label. The labelling led to a marking of these women, as the women were equal to prostitutes. The victims were referred to as "violated women", "dishonoured women", "the victims of military repression" and even going as far as being referred to as the "poison of 1971." The term "birangona" had opposite effects because it became infused with the local context. These women were regarded as "soiled" and shunned; it served as a warning to darker times. A key component of the rehabilitation procedure was marriage. However, most women did not remain in marriages after receiving financial compensation from the state.

Women were not agents of their change. In a backwards stance, the rehabilitation procedure rewarded men with employment and financial compensation, in their willingness to "transform" these birangonas into obedient wives. Once again, women lacked true autonomy.[28] Toxic societal pressures ensured that the once respectful 'birangona' concept fit patriarchal ideals. Justice served the men and left the women to social neglect.

Further research into this notion has demonstrated the women themselves were not in control of their testimonies. In The Spectral Wound, Mookherjee describes how a victim, Kajoli, "tries to narrate what happened to her when she was raped but was interrupted again and again by her husband, who wanted to correct her on what took place - for him, she did not know how the events of the war well enough to be able to narrate them correctly."[29] There are descriptions of Kajoli's husband, prompting her to speak louder and pressure her to

describe the rapes in great detail. However, Kajoli ended the interview as "she should finish her work, or she would not get paid."[30]

Whether her husband's intentions were condescending on purpose is unknown. However, it is clear to see a recurring theme throughout this discussion. Time and time again, people have assumed a guardian role over female victims and dictated their choices. If women were free to bear witness and truthfully tell their story, it would heal society. We would be able to repair the human dignity lost, but we have not created the space to do so. Not for one second, did anyone take a step back and truly consider what the woman wanted to do?

In the award-winning documentary, *Rising Silence*, the director Leesa Gazi seeks to preserve the testimonies of the 200,000 women that were abused during the war. The statements are harrowing, with victims showing sites where atrocities took place. The soldiers would take the women wherever they saw fit, and the bodies were used.

Many of the women are now weak and frail. Their burdens have not been recognised by society or state. Nor has the loss of their livelihoods, their children or their families. The sexual violence wounded the women for their entire lives. It affected the politics of their home villages. As a result, these women are victimised consistently. Their stories are dying out and must be heard.

Rising Silence is an example to us all, as Gazi herself was only a teenager when she first heard of the "Birangona" women, but as I have found, these stories are absent from history. Nevertheless, witnesses cannot forget the sights they saw. They cannot forget witnessing hundreds of women be carted back-to-back in trucks to Dhaka.

Trauma and distress suffered by the women were ignored because purity was given the highest priority in nation-building discourse. The original, positive intentions of the concept backfired as the term "Birangona" was purely used to identify these women, who in turn suffered public ostracism. The usage of media-assisted with the ostracisation of women. For instance, pictures were issued in

newspapers, which circulated back to the remote villages. The images became a source of shame for women, who were charged with violating "local codes of modesty and protection through silence."[31]

Often, organisations would assume monopoly over the victim's' testimony; it appeared that in the name of agendas - statements would be publicly told and displayed in the name of "justice." A woman's body has become a territory, in which political agendas are inscribed. However, no-one seemed to consider the personal ramifications these acts would have for the women. Did no-one find the "struggle to take back authorship that wrestled away from them" as Mookherjee so eloquently put?

In further analysis, we see that media publicity of the birangonas was executed distastefully. Thus, it subjected women to everyday scorn in their villages. The women and their families would be stigmatised for letting their struggles with sexual violence be made public. To be re-assimilated as citizens into the new nation, they would have to be "cleansed" and be free of any remnants of the enemy.

The state's approach to the whole ordeal is still regarded as a bold effort towards the war victims. These attitudes were internationally unprecedented, namely the state rehabilitation centres and the public support for raped victims through political rhetoric. This toxic mindset was so entrenched in society that one truly feels as though women honestly had no choice in the decisions that were made on their behalf.

Women should not be underestimated, as we have conquered a lifetime of trauma and risen above it. Violence may attempt to destroy us, but it cannot obliterate it. Therefore, a more excellent agency should have been placed on women in the aftermath.

The notions that surrounded the aftermath of the mass rapes were that it was a topic that could not be discussed–the focus was on erasing the country of any recollection that it occurred at all. The statistics have transformed the raped women into faceless victims. We cannot accept this, as the telling of women's experiences is necessary to uphold their

intrinsic value as human beings. We must preserve their truth by going forward.

In recent times, feminists have begun to address the issues and embraced the story into the nation's history. Renowned feminists such as Shireen Huq and Firdous Azim remarked that they are shocked at their past apathy towards the rape issue.

In despair, anger and frustration, Shireen notes that "everyone tried to tackle the problem with the same patriarchal mindset, trying to sweep it away as soon as possible." That is not surprising, as there is a dominant understanding that sexual violence should be rewarded with silence and ignorance. There is a real fear of subjugation for speaking against gendered violence. In a world where violent conflict is rife in history, sexual abuse is believed to be a war cost.

Perhaps this explains why the struggles of these women are not common knowledge. It is no secret that women's status tends to be responsible for the violation of fundamental rights by society. According to the United Nations Development Fund for Women, statistics demonstrate that 1 in 5 women become victims of attempted or actual rape in their lives.

The emphasis on the wounded woman creates a pathological attitude whereby raped women are reduced to the horrific crime of rape. We must not resort women to victimisation, but assert their resilient role in the liberation of Bangladesh. Otherwise, the public sphere becomes mesmerised by stories of suffering - the wounded are treated as a spectacle. Therefore, there is a push-and-pull between the public's interest, but need to shy away from the truth.

This focus on keeping the war rapes hidden from public sight resulted in the state's two-tier "cleansing process" whereby there were purely two options: abortion or adoption. As expected, the restrictive approach was not welcomed by all women. Maleka Khan witnessed internal conflict many women were subjected to, as some felt close to

their children and did not wish to abort or adopt; however, their wishes mattered very little.

In Maleka's words, "the decision to push abortion and adoption were responses to the demands of the time and context and the only option available which was both practical and pragmatic." As Bangladeshi society was constructed in a particular way, there was a sudden realisation that it was necessary to give their children away; it would be almost impossible to get married and start a new life with them. It is incredibly shameful that the focus was solely on marriage. After the absolute torture endured by women at men's hands, their lives were once again placed firmly in men's hands. With the loss of "moral purity", the women had forfeited social status.

It is truly harrowing to hear their experiences, with some having to be sedated due to hysterics. Maleka Khan recalls that "many girls did not want to give their babies away. We even had to use sedatives to make the women sleep and then take the babies away from the mother."

The narrative of the above extract appears to paint the women in soft, fragile light. That is not the intention. There seems to be a predetermined focus on documenting and presenting only a horrific outlook on their experiences within a human rights perspective. There is inadequate attention on how the war heroines wish to be portrayed. No woman is invisible. No woman is fragile. These women deserve our utmost respect for finding the light at the end of the tunnel by reshaping their lives because, in truth, there was a deep fear in these women that no one else would.

Nevertheless, not all was lost. In the wake of assumed silence surrounding wartime rape, feminists and activists believed it was their imperative duty "to give voice to raped women's narratives."[32] Silence is the language of trauma; we cannot honour without speaking our truth. If we do, the trauma undermines our power.

It is heartening to see the love and support these women received from the sisterhood. Bangladeshi women went above and beyond for

these women, empowering them to be financially independent and make a name for themselves.

Feminist organisations, such as Bangladesh Mahila Parishad, Naripokkho, and Women for Women and many individual feminist figures, were instrumental in fighting for their sisters. The solidarity was established through rehabilitation plans. Many women suffered at the hands of hostile communities in remote villages; helping women in these villages through vocational training and litigation was a particular focus.

The aim was to encourage financial independence, allowing them to make crucial life decisions in later years confidently. The "Bangladesh Freedom Fighters Trust" further demonstrated these campaigns. The initial purpose of the trust was to support disabled freedom fighters. Still, many women were rehabilitated through the programmes utilising financial aid, vocational training, and scholarships to assist with the continuation of studies. The rehabilitation programmes were essential in providing "self-sufficiency and independence to women"[33].

The emphasis on educational support is significant, as many trustees were unmarried, widowed, or abandoned women. The advancement of educational support effectively elevates women's benefits, leading to the country's more successful development in its global stance in the world.

It is incredible to see that while society may not have been ready to empower these women, some beautiful people stood by their side. Nonetheless, it is undeniable that the majority of women only received support from their fellow sisters. Instead, these women should have been treated with great compassion on a national scale.

The efforts put forward by the Bangladeshi state indeed remain unprecedented in history, whether it was considered a success or not. However, no matter the year and no matter the past, women should never live purely to fulfil men's wishes. It is heartbreaking to become

enlightened on this subject and realise that the women of the Liberation War were not vindicated for their traumatic experiences even to this day. If society does not accept its vulnerable citizens, it is the state's responsibility to be responsible for the situation.

If we dismiss these historical stories of sexual violence, it shall never stop. We cannot treat these accounts as isolated incidents, as sexual violence and rape are consistently used in armed conflicts. Bangladesh is not unique to this.

Sexual violence deprives women of any sense of control, autonomy or privacy. We must learn from the harrowing tragedies in 1971. The legal system must seek to restore women of their safety and dignity. It is clear that the current legal instruments do not adequately protect gender rights, and therefore a coordinated effort must be put in place. So, sexual violence can be eliminated.

Society tends to shift away when women are in need, so we must be there for one another. Women and children are always the first casualties in the conflict. If we wished to bring dishonour on a family, we would target their daughters. If we want to dishonour a country, we aim at their daughters. As a consequence, this is a mindset that transcends time and is present in all wars. A mindset we must stop.

These women have harboured the inner strength to build themselves back up after facing the most physical and emotional abuse. Their will to survive and keep fighting in the face of rejection is a real testament to the human spirit. It is a true shame they were left on their own to do so.

The country was liberated, but our women were not.

THE BIRTH OF THE REVOLUTION

It is not difficult to see that the lack of support towards women at the beginning of the country's liberation had severe ramifications on how male members of society treated them. Despite the proactive attempt by feminist organisations to welcome women back into the community, the desperate need to silence the discussion of rape culture and wish it away manifested into severe disrespect towards women, thus leading to an uncontrollable amount of heinous misogynistic crimes. From both the enemy and the homeland, women have been humiliated and dishonoured. As women are reduced to objects, gendered violence is a common occurrence.

Acid attacks on women, for instance, have become commonplace to the point where people are now desensitised to the issue. Acid attacks are the usual weapon for assault crimes in Bangladesh. It is a debased form of aggression. As a critical human rights concern, it creates a more significant public concern for Bangladesh. The recovery takes a considerable amount of time, and because of the physical disfigurement - many victims are left psychologically debilitated. The social isolation from their communities leads to great difficulty in other life opportunities. Namely finding employment and often staying unmarried. Not out of choice.

The theories behind why acid violence is committed are plenty, but the basis is the same for all other forms of violence against women. To keep them in their place. As masculinity within Bangladesh is determined by a man's ability to defend this honour. Therefore, by destroying a woman's appearance bolsters the political power over women.

In our society, marriage determines the social status of our women. The marital alliance ensures economic security, so the only resources a woman possesses is virginity and appearance. If either is destroyed, it ruins the woman's chance to secure a financially beneficial marital match. We *must* not ignore such an issue, as it is real life-orientated.

Therefore, the world must band together to investigate how to rid the world of such abhorrent attacks.

If a woman *is* financially prosperous, she is not immune to acid violence. As a woman becomes more independent from men - it leads to more hostility and resistance from traditional men. Ashma Begum was the sole breadwinner within her family, as she worked in the garment factory. One night, she returned late. Her unemployed husband was irate as dinner had not been prepared. As punishment, he threw sulfuric acid at her.[34] This is not a rare occurrence. Many women have suffered in the same manner, but are afraid to report it to the police. The fear of retaliation from the attackers is too intense.

Over 80 per cent of the acid violence targets women, with at least 40 percent of female victims falling under the 10-30 age group. [35] When Maleka Khan first came across the ferocity of acid attacks, she was ashamed by the "inadequacy of care and facilities to tackle the acid burn cases." The state failed to provide primary medical care for these acid attacks. Therefore, local activists took it upon themselves to organise with international activists in pressuring the Bangladeshi state into providing acute medical care to acid burn victims.

The failure to enforce laws against attackers led to local feminist groups in mobilising against acid victimisation. Many feminist figures have made it their mission to rid the country of acid attacks due to the accessibility to the liquids, thus exposing women to violence at all times. For example, Nasreen Huq has dedicated her time in ActionAid to mobilising foreign funding and continuing the fight against acid violence.

Feminist organisations possessed a unified focus on all fronts to eliminate acid violence. A continuous dialogue between the state and non-governmental organisations took place, repeatedly demonstrated by Naripokkho, who advocated between state officials, members from civil society, doctors, and survivors. This feat is incredibly essential because it highlights that feminist organisations recognised the societal

flaws early on and were willing to host difficult discussions to achieve actual progress.

Although state officials were involved in tackling acid violence, a more significant state presence was required. It would benefit both NGOs and the state for there to be a collaborative partnership between the two. For non-governmental organisations, working with the state opens an opportunity to expand the scope of operations and broaden influence in the national development agenda production.[36]

In regards to the state, collaboration with non-governmental organisations would offer a chance to reflect national pride in its citizens' interests and achieve a more efficient implementation of policy with all parties contributing with a diverse scope of experiences in bettering the lives of the Bangladeshi people.[37]However, at the time of acid violence - the tension between feminist organisations and the state were still rife. Therefore, as a result, feminist organisations utilised physical demonstrations in the city capital to showcase their strength in numbers and voice.

The most momentous occasion was the first torch procession with survivors in Dhaka's streets in 1997, whereby women gathered in front of the parliament demanding punishment and legal support. It became evident that these cases needed long-term interventions, which would not be possible without state support's mobilisation.

The torch processions were beautiful to behold, as it gave women the confidence to defend themselves. The birth of a feminist movement could be felt as Firdous Azim describes:

"At the beginning, they were all hiding their faces and bodies and did not open their coverings. However, at some point, they took off their covers. They were feeling free, and this we thought was an achievement. Thus, the torch procession was a symbolic event through which we could unveil the faces to the public."

There was no shame in being a victim, nor was there shame in being a survivor. Most importantly, there was no shame in being a woman.

In the present day, Bangladeshi citizens are being attacked by acid through both genders, but women continue to be the primary targets. According to UNICEF, there was an overwhelming number of female victims. These women were being attacked for various reasons, ranging from rejection of sexual advances from men to family disputes.

It is profoundly worrying that with the increasing number of acid attacks, there has been a consistent lack of medical care for victims of gender violence. For instance, a report produced by Ain O Salish Kendra, a legal aid group in Bangladesh, stated that gender bias was widespread within the medical profession. The report described the experience of a rape victim. In the hospital, the "nurse aids would not touch[her]." The doctor had advised the nurses that "there was no indication of any injury on [her] body."[38] The medical reports concluded similar findings. Victims are subjected to multiple medical testings, but the feeling appears that these testings will amount to nothing because the likeliness of justice coming to the perpetrators is slim.

In the past, the system was built on bureaucratic rules that hindered significant tests. For instance, forensic tests only being conducted via a deposit of photographs of the victims. This burden would fall on the officer on duty at the police station. It can be concluded that the collection of medical evidence remains at an inadequate standard. The severity of doing so should not be underestimated, resulting in severe consequences for effective prosecution.

It is not the only difficulty in obtaining medical evidence that hinders true equality in prosecutions. Badrunnessa Khuku, the Legal Unit director at the Acid Survivors Foundations, highlighted the complicated process of seeking justice under the current system. She believed that the different groups involved in the process are at odds with one another. It was further argued that "abuse of power occurs at every level. The investigation process takes anywhere between 4-5 years,

so pending cases fall on the wayside. One rarely sees cases reaching completion."[39]

Assistance from both national and international organisations have been monumental in bringing justice to acid attackers. At the centre of the co-operation are Bangladeshi women's groups, who spend day and night mobilising against acid attacks. It has led to successfully motivating all groups in providing medical care to acid survivors, and the role of women's activists has been the most crucial. Nevertheless, we can see that the work is not over. If we are to meet every victim's physical, psychological and social needs, the state must do all it can to influence society in a positive light.

It is not only in acid violence where the different treatment of men and women exists. As women's social empowerment undermines classic masculinity, men resort to domestic violence to enforce dominance within the home and public space.

It is believed that 1 in 5 married women experienced domestic violence within the past year.

As a result, the reduction of domestic violence is a necessary Sustainable Development Goal for Bangladesh. There have been studies investigating the methods to reduce domestic violence, concluding that education is at the heart of it all. Higher educated communities provide women with the infrastructure to openly condone domestic violence. As a consequence, empowerment is normalised. If a woman's empowerment can be viewed as the norm, it shall allow women to build the financial foundation for autonomy and self-sufficiency.

Empowerment can be achieved by holding institutions accountable for their effects on people's lives. Education is essential in women's empowerment. Therefore, both the state and NGOs must stay focused on improving education equality for all citizens. Women must be active agents in the development process and exercise their freedom to act progressively in all capacities.

There is a more excellent community spirit in protecting vulnerable women, as bystanders may intervene when violence is committed. It has been proven throughout the text if women are more involved in earning potential and educational opportunities, it shall create social transformation. The Female Stipend Support Programme provided that opportunity. It was piloted to enhance women's secondary education. As a result, there is a greater sense of empowerment, marriages are delayed, and the economic capacity has expanded.

As a consequence, women's lives are improved, and there is a reduction in gender inequalities. Therefore, when it comes to marriage at a later age, women are in a more freeing position to create a better life for themselves and their families. All must stay committed to this because if we focus on empowerment, we shall reduce women's unequal vulnerability in society.

It is clear that significant social change causes instability as it shakes the patriarchal foundation, but this is vital for greater freedom. The culmination of feminist development, employment and education policies shall create confidence in combatting male backlash. The feminist movement must prioritise communities coming together to fight against sexist violence.

The Bangladeshi feminist movement standing by innocent women has been manifested in landmark cases, such as Shabmeher and Yasmin's death. Both were two different women of different occupations. Still, both died at the hands of men. The differences between them are essential as they determined the reception of the cases and how the feminist organisations received each woman.

The death of Shabmeher holds significance with the perception of prostitution in the country. Shabmeher was a young adolescent girl who died on 9th April 1985. Her case contains harrowing details describing Shabmeher's alleged torture for seven consecutive days by brothel madams in the Tanzabar brothel in Narayanganj, near Dhaka. Following her death, conservative Islamic groups began to mobilise and

evict occupants from brothels in Islam's name. In their eyes, this would lead to building mosques; however, opponents of these Islamic groups have alleged that this was merely a scheme to obtain more land.

The portrayal of Shabmeher's death has invoked mixed responses. Some regarded her death as a liberation from the filth of the world. Regardless of her occupation, murder is murder. It is abhorrent to believe that despite being tortured endlessly and killed so young, all of this was acceptable because she was a prostitute and needed to be saved, whatever the means.

Sex workers are heavily marginalised in Bangladesh and placed in binary opposition to "good" or "ideal" women in a traditional ideological framework. As a result, they are not given the same legal respect than other professional groups, with the question of justice and rights from a "moral standpoint."

Women in the sex industry have been reduced to the necessary "safety valves" for society to curb sexual aggression. This opinion is shared by other feminists, such as Maleka Khan who believed that she was not "simply a prostitute killed by pimps", but a woman, who had travelled to Dhaka on the promise of a better life. When she had refused to enter prostitution, the consequence was death.

Shabmeher's death is not rare, nor is it unusual. She represents the lives of countless other women, who have either turned to prostitution or been coerced into it. Nevertheless, her death is unique in that it began a line of questioning on the state of law and order and the violations of human rights. Moreover, she was a victim of poverty; thus, her death further demonstrated the severe crisis in socio-economic rights, in which women were a high number of casualties.

Debt magnifies a woman's vulnerability to rape. Such dependency allows women to be more susceptible to sexual exploitation; thus, financial debt disrupts every life. Additionally, the pressure exposed flaws and inaccuracies in the Bangladeshi legal system. Therefore, it led

to considerable demand for opportunities for women so that the sex industry could be removed from society.

Firdous summarised that the entire process revealed "the nature of sexual politics within the women's movement" and the wrong perception of women by Bangladeshi society in its entirety.

However, it is interesting to see that the whole structure under which Shabmeher died was not addressed—the focus was on the fallen woman, not the fallen society. More importantly, the case was narrowed to purely prostitution when, in fact, the violence Shabmeher suffered further takes place within the family. The existence of sexual abuse exists within the family home, more than in "stranger towards random victim" circumstances.

Critique of the narrow view led to conflict between Naripokkho and Bangladesh Mahila Parishad. Naripokkho believed that the latter organisation created division by differentiating between "good women" and "bad women", with the trap of categorising women as either label merely based on their conduct. In times like this, there was a desperate need for solidarity within the women's movement, rather than personal opinions taking priority.

On the other hand, there is little evidence to suggest that Bangladesh Mahila Parishad was categorising women as "good" or "bad." In reality, the organisation took an objective stance by focusing on societal structure. Women under the leadership of Bangladesh Mahila Parishad highlighted that Shabmeher's death was a failure by the state to ensure security to women. Does it raise an important question: was security and safety lacking due to Shabmeher's associations with prostitution?

One cannot deny that women in the sex industry have been disregarded and do not have the same security as other women. Nonetheless, other landmark cases denote the severe lack of measures placed to protect Bangladeshi women, despite their occupation. A

situation that immediately comes to mind concerns the death of Yasmin.

This case is as harrowing as Shabmeher's death, perhaps more so due to the rapists in question. On 24th August 1995, Yasmin, a housemaid in Dhaka, had been travelling to see her mother; her occupation is vital because it reveals that not only female sex workers suffer at men's hands. On her travels, policemen promised to transport her home safely from the bus station. Instead, the policemen brutally raped and murdered her. As a final insult, her body was discarded at the roadside.

Yasmin's brutal murder sparked a militant movement following the press statement denying the rape and claiming that she had died in an accident. More shockingly, the report indicated that Yasmin had been a prostitute. This is incredibly infuriating and quite frankly sickening; Yasmin was raped and mutilated by three policemen, men who had sworn an oath to save and protect citizens, and all of this was dismissed by the state, which further defamed her by insinuating that she was a prostitute.

It does not matter if she was a housemaid, a housewife, or a prostitute—no woman deserves this experience in the last moments of their life.

Her death created mass demonstrations with militant protests. It became a rallying point for activism against violence against women, with mass support from both men and women alike. Many men put their lives on the firing line for the cause. People were much agitated, as they believed that the administration did not react appropriately; ministers appeared to have no intention to resolve the case.

The country awoke to the devastating state it had become. The severity of the crime resulted in the most severe punishment: the offending officers were arrested in 1997 and put to death in 2004. The prosecution's success arose due to heavy pressure against the state from both feminist organisations and civil society. The critical date of

24th August is now deemed the Resistance Day Against Repression of Women in Bangladesh.

Roushan Jahan believed that the movement's most notable achievement was exposing the police's role and articulating the insecurity of citizens, particularly women in the hands of authority figures. The tragedy of Yasmin and the subsequent anger over her death helped bridge the divide between the masses and the women's movement, thus strengthening the solidarity between organisations within the movement. It was instrumental in bringing the protests and agitation to an international forefront.

In the present day, we are still witnessing the general public taking the side of the victim. In January 2020, thousands of student took to the street to demand justice for a rape victim. The rape of a second-year student was broadcasted across the country. There were demonstrations for two consecutive days, forming large human chains in the capital and demanding more excellent safety for women on the roads. Forceful banners were demanding "no more rape, we want justice" and "we demand justice for our sister."[40]

As part of the moment, four students went on hunger strike, and the fiery protestors delivered an ultimatum to the state with 48 hours to make the arrest. The demonstrations were publicly backed by women's organisations, such as the Bangladesh Mahila Parishad, and other non-governmental organisations voiced their support.

It is beautiful to see the ferocious backlash against perpetrators abusing their privilege. However, these cases spotlight the fundamental fact that women were unsafe in the current legal system. By keeping in place such loose provisions, the system is complicit in perpetuating and sanctioning misogynistic violence.

In the past, Meghna Guhathakurta argued that Bangladesh had become a "soft state", which is unable to firmly implement its state interests. Instead, its policies cater to diverse and (often) fragmented parts. For instance, "the rural rich, the urban middle class and certain

state functionaries like the army and the police force."[41] This fragmentation reflects heavily in the contradictory nature of policies and practises - especially in gender-related issues. Guhathakurta believes the state to only intervene at a superficial level.

In reality, it does little to challenge existing discrimination amongst gender relations. This notion must be challenged because the dealings of a "soft state" will only lead to further internalisation of male-dominant values. Thus, strengthening the oppressive subordination of women. These severe cases demonstrate that there is a need for preventative measures in sexual violence. An example that comes to mind is prevention programmes for men to rehabilitate those with violent tendencies towards women. This would break the cycle of normalised transmission of violence towards women. As a consequence, the notions of sexual rights and consent will be widely promoted amongst men.

One merely needs to look at the numerous cases of violence against women in dowry issues and deaths, where the entitled greed for marriage on the part of the groom has led to the most tragic and violent deaths. In similar fashion to Shabmeher and Yasmin, the iconic case of Saleha Begum's death in 1978 was a crucial eye-opener in dowry's pervasiveness. It proved that the dowry-related deaths were not exclusively poverty-related problems and a social practise that cut across class and gender.

Saleha Begum was killed by her husband, Dr Iqbal, on 18th April 1978. The marriage arranged that Saleha's parents would bear Dr Iqbal's medical tuition and others as dowry. As time went on, Iqbal insisted on more, culminating when he finally killed his wife. The justice system moved in favour of Saleha and sentenced Iqbal to death on 5th August 1978. The verdict and its implementation were regarded as an accomplishment for the women's movement. Nevertheless, it simultaneously revealed the entitlement that men felt towards women had sunk to a dangerous low.

Saleha is not a rare case; many women suffered at the hands of their betrothed in the name of money, but there was a final recognition on behalf of the courts that this atrocity could not go on. Elements of the dowry system have led to multiple demands. Studies have found that the "husband continues to make demands from his in-laws long after the wedding."[42] As a result, it is believed that 85% of women become victims of oppression through the connection with dowries.[43]

The notion of a dowry demand has been notoriously known for increasing the likelihood of gendered violence. Odhikar, a human rights organisation based in Bangladesh, produced a report in 2007 that 138 women had been killed, with 47 tortured and 13 have committed suicide in dowry-related incidents[44]. The misogynistic dowry system relates to other issues, as it is a crucial motivation in the lack of opportunities extended to women. For instance, educated grooms tend to demand higher dowries.

Arends-Kuenning found that "some parents intend to limit their daughters' education before they complete secondary school because they are concerned that they will not be able to pay the dowry for an educated groom."[45] As a result, the daughter has not been involved in the decision-making. The decision - making powers are left with her male guardian. There have been quantitative studies, which reported that "young, illiterate and poor women were more likely to experience this violence while women participating in micro-credit programmes or contributing to household income were less likely to be exposed to it."[46]

It should be highlighted that a dowry is not compulsory in marriage. A demand for a dowry is at the groom's discretion, and there is no equal transfer of financial gain between the two families. Therefore, a dowry demanded at marriage is a primary indicator of patriarchal attitudes within the groom's household. It is a clear indication of potential violence towards the wife.

It is true that, on face value, there are intentions to treat women with equality and fairness. The Constitution's declared objection is secure justice, liberty, balance, and fraternity to all citizens. Therefore, the preamble expressed the need to promote diversity in political, moral, and religious values. Regardless of this, the details concerning protection for women are scattered and incoherent, as it lacks consistency with other rights and clauses. As demonstrated previously, the Constitution clearly states equal rights for women, but due to the provisions' inconsistencies, many oppositional legal loopholes in the folds have been allowed.

The personal laws in Bangladesh have identified a threat to women's equal rights in the family. In addition to this, the legal framework is riddled with ambiguity regarding "sex work" or "prostitution." This is not to say that those who crafted the Constitution were insensitive towards Bangladeshi women; instead, they were integrally part of a system caged in a particular moment in history, which placed women on the backpedal. Thus, this shaped their conceptualisation of women and led to the Constitution that we have today.

These double standards built into the Constitution have led to the further disintegration of radical change, thus disallowing real progressive transformation in women's lives.

These instances led to the Dowry Movement, which pushed for an Anti-Dowry Bill. There are clear signs that programmes addressing violence are critical. At this present moment, there is no legislation criminalising sexual violence within marriage. This reflects the toxic cultural beliefs about masculinity. The Anti-Dowry Bill has received support from all sectors of the state and civil society. Nevertheless, very little has progressed to date, and pressure must be maintained to ensure that all violent acts against women are eradicated.

If we are to push for no violence against women, we must make economic prosperity for women. Women must push forward in the financial world, and not allow the hardships to hinder them so.

Suppose women can generate income for their families or themselves, with the support of state actions and increased accessibility for vulnerable women. In that case, it shall lead to more extraordinary companionship between men and women.

The state and non-government organisations must continue to play a significant part in women's advancement. A more outstanding contribution to promising women's economic autonomy shall create options for survival beyond the marriage. No longer shall women be treated as commodities in marriage or dowries, but women shall finally be able to assert themselves and build an independent life.

The increased financial collaboration between all citizens shall diminish the concept of traditional gender roles. All must be involved. The part of state and non-governmental organisations shall create realistic alternatives to harsh circumstances. The promotion of equal rights shall empower women to take action against oppression within their communities.

It is the fragility to masculinity that has placed women in such danger. As women gain higher power in society, there is the potential for more considerable hostility. Therefore, any progressive policies may be met with patriarchal resistance. However, this should not deter positive transformation. The continuous support from the state and NGOs must continue. It is paramount to sustain protection for women.

If men are no longer ashamed to adapt to performing traditional feminine duties, and women are no longer afraid to pursue life-changing opportunities - change will come fast.

THE BIRTH OF BODY POLITICS

"**M**y Body. My Decision."
 It is expected for a Bangladeshi woman to birth children, as marriage and family-building are seen as a natural stage in life. This belief tends to be the reason as to why women's participation in education and the workplace is so low, as women prioritise fertility more. Therefore, infant and child mortality rates are high.

The fertility rate has declined in the last two decades, but there is insufficient evidence to suggest that the Bangladeshi demographic has been completely transformed. With the modernisation of socio-economic infrastructures, it is no surprise that urban fertility is lower than rural communities, as a woman's independence is normalised. Therefore, the fertility rate tends to be smaller.

The difference between urban and rural fertility rates has sparked a discussion on the attributes, which may have given reason to this. For instance, working women in urban communities tend to delay their marriage and stay focused on improving economic self-sufficiency. It is perceived that an economically-advantage woman has a more significant opportunity in family decision-making, and there tends to be a lesser power balance between the husband and wife.

Often, greater female independence enhances the usage of contraception in urban and rural Bangladesh. Nevertheless, the husband's authoritative power is rife in Bangladesh and may serve as a barrier to the use of safe contraception. In many communities, the presence of men within the household guarantees financial security. Thus, the patriarchy has imposed insecurities upon women.

Women are estimated to live longer than men, and the significant systematic structures have ensured that women cannot secure land on their own. Therefore, there is a greater incentive for fertility. It rarely matters if the females involved do not want children; the reproduction of sons is the best option. Otherwise, a woman's welfare is too uncertain.

Contraceptive use is accelerating in Bangladesh. It seems that whether the woman dwells in an urban or rural community does not have a substantial effect on whether contraception is used. However, it does open the door to conflict over the use of abortion as a means of body politics.

Bangladesh is fraught with conflicting opinions over a woman's right to abortion. Despite the open approach towards abortion in the Liberation War's aftermath, these attitudes did not prevail today. Under the Bangladeshi penal code, abortion itself is illegal in Bangladesh, except to save the mother's life. Following the mass abortions after Operation Searchlight, there was an attempt to pass through a bill legalising abortion through Parliament. This bill failed to pass. As an alternative, the Bangladeshi state has maintained the practice of "menstrual regulation".

Once a woman falls pregnant, menstrual regulation is used to remove the uterus' linings before a positive pregnancy test. This practice must be carried out before 12 weeks of the pregnancy cycle. The medical practice successfully passed through Parliament in 1976. The act of "menstrual regulation" is seen as the perfect compromise. It provides the same results as abortion without engaging with the law. Therefore, it eases the traditional anxieties of the era, to which it emerged. In the words of Rasheda Khan, a Bangladeshi anthropologist, "it addressed a problem without waking the sleeping lions - the religious fundamentalists."[47] Besides, this compromise allows health workers to understand that abortion is a woman's right.

Nevertheless, the public health facilities in Bangladesh are extensively under-resourced in these practices. For instance, Bangladesh has trained female paramedics and welfare visitors to perform procedures. In 2014, it was reported that only half of the welfare visitors are capable of carrying out safety procedures. It is argued that there is only one doctor in "menstrual regulation" for every 2,000 of the population[48].

Despite the accessibility to menstrual regulation, many women are subjected to clandestine abortions. Restrictions of movement, their familial relationships and community networks can severely hinder their confidence in health facilities. The traditional concepts on menstruation believe it to be taboo. Thus, there is an element of secrecy and seclusion with menstrual regulation procedures.

In 2014, it was estimated that 384,000 women suffered severe complications due to illegal abortions, otherwise known as "backdoor abortions"[49]. Also, a third of pregnant women did not receive the post-abortion care they required in facility-based treatments. The most common complications appear to be haemorrhage or incomplete abortions. As one would expect, incomplete abortions lead to critical complications — for instance, sepsis and uterine perforation.

There is a detailed history of women's lives at risk due to abortion prohibitions. The state may have supported the "menstrual regulation" programme. However, there has been no active effort to ensure that women are aware of their services. The National Demographic for Health recorded that more than half the married women within Bangladesh had not learned menstrual regulation[50]. If women seek menstrual regulation, they are discouraged from seeking menstrual regulation at approved health facilities because there are structural barriers. For instance, there have been harrowing reports of facilities refusing to provide M.R services to women from the very beginning. In 2014, the figure had stepped to 105,000 women[51].

The reasons for rejection vary - however, the most common has been the medical practitioners' cultural values were not reflective of the state guidelines. For menstrual regulation to be administered safety, it must be accepted at a community level. Therefore, the broader context of domestic lives needs to be accounted for.

This is deeply concerning because we have detailed demonstrations of conservative values infringing the lives of women. Women in

Bangladesh live within a patriarchal space, where it is impossible to act outside the community and social systems. Therefore, women who need menstrual regulation are influenced by structural aspects. Stigma against women is rife in Bangladesh. As a result, the stigmatisation can lead women to seek information about menstrual regulation from trusted relatives.

The general knowledge of menstrual regulation is weak, and therefore there is a greater trust in "backstreet abortions", which then lead to dangerous consequences. Often, women are being subjected to "backstreet abortions" with unhygienic facilities. Unsafe abortion is officially known as an "a procedure for terminating an unintended pregnancy that is carried out either by persons lacking the necessary skills or an environment that does not conform to minimal medical standards or both."[52] It is profoundly worrying about the commonality of unsafe abortions.

Therefore, the state must take an active interest in educating women about "menstrual regulation" services. In the present day, rural women are less likely to seek care from approved health facilities because the costs are too high. Formal health facilities within rural communities tended to charge 500-1100 Taka, and urban health facilities did not differ far with costs ranging between 800-2100 Taka. In contrast, informal providers charged 300-400 Taka[53].

The difference is astronomical, so it is no wonder why women prefer informal providers because it is impossible to pay for safer procedures. Therefore, there must be an assurance that women are aware of this free and legal alternative to unsafe abortions. As a consequence, there shall be a reduction in unintended pregnancy rates. The damning evidence is a demonstration that there is an intrinsic disregard for women's protection in the name of outdated cultural beliefs.

An immense movement was born from the disregard of protection for women. "My Body, My Decision" was created by Naripokkho in

1993, with mass rallies to amplify the messages; it criticised the population policy of the state, as well as the harmful methods offered to women for population control. Bangladesh was a small country with the threat of over-congestion existing as a constant presence. There was a severe abuse of sterilisation, a lack of safe delivery services, safe contraception, and respect for reproductive rights. Population control became problematic and dangerous when it infringed on citizens' autonomy—primarily; women were the ones to suffer first.

The formulation of this feminist movement was heavily criticised by right-wing religious groups, whereas the state remained nonchalant to feminist efforts. The concept of women possessing autonomy over their bodies was perceived negatively by the general public and even other women organisations. The concept of body politics unsettles men's roles as the decision-makers; it promotes gender equity by women taking full control of their lives. This is evident in the slogan "My Body. My Decision" being regarded as projecting the demands for sexual freedom by radical women; in translation, many believed that women were demanding promiscuity.

Two crimes were committed here: firstly, shaming women for demanding sexual freedom and in turn, "slut-shaming" the relevant women; secondly, women turning against women.

Instead, the movement began purely to allow free will in regards to sexual freedom. Indeed, women should have the real choice to decide whether they wish to birth children; it is not the spouse, partner, or state's responsibility to determine the matter. It is illogical to allow those who do not have to sacrifice their bodies to make the final choice on a life-changing decision.

It is an infringement of human rights to put women through harmful methods of population control. Furthermore, it is a crime to imprison a woman's body for decisions regarding their bodies. The very fact that abortions exist shows that agency and resistance will always be dynamic, no matter how oppressive space may be.

As the reproductive rights activist, Merle Hoffman once said, "that is the most difficult thing for people to accept - that the women are the ultimate arbiter. Not the state. Not a judge. Not a group of 'ethicists". It is the woman's choice concerning how she wishes to use her body, whether that is to be sexually free or uphold chastity. It is her decision, and only hers.

The movement centred around three issues, which formed the "private" aspect of women's lives: the dowry, the Uniform Family Code, and women's constitutional rights. As a result, taboo subjects were brought to the forefront, leading to progression with every step. No matter how small, these efforts are always a step forward in history. For instance, the Anti-Dowry movement was a significant achievement because it defeated a vital factor in violence against women. Despite the internal conflicts and misunderstandings, the women's movement proved its capability to fight against daunting issues and emerge successfully.

Moreover, "My Body. My Decision" was important because it brought female body autonomy into the public discussion for the first time in Bangladesh. Preconceived ideas were challenged, with assumptions broken and taboo topics carved out in public discourse, thus opening grounds for review within feminist organisations and outside.

Nevertheless, there is a limitation in progressive movements as traditional laws do not interconnect with new liberal ones. If there is no streamlined implementation process, new regulations can be overridden in practice and become meaningless. It seems that society is unlikely to understand and accept these changes unless there is machinery to implement their significance.

However, that is not to say that the legal system is rigged not to support women as there have been momentous achievements for women's rights in Bangladesh.

The movement surrounding bodily autonomy maybe for all women; however, it cannot be denied that there needs to a severe level of protection for sex workers. It is hypocritical that there is an extreme demand for prostitution, yet a severe lack of protection for prostitutes. There has been a history of brothel eviction, which created a reaction from women's organisations and non-governmental organisations. These movements were launched in the exiles' face, as feminist organisations recognised those sex workers had rights to a home and earnings. The brothels had become a safe place for sex workers, rather than be out on the streets. As a result of these evictions, these sex workers could not find shelter elsewhere and were taken into rehabilitation centres.

It is alleged that the workers were kept in prison-like conditions and were only released with a measly monetary sum. However, this lack of regard for their well being only inspired the wronged sex workers to fight for change. There was a genuine camaraderie between sex workers and women's' organisations; this is demonstrated by the demands of sex workers taken up by the relevant organisations. A written petition challenged the evictions of these brothers along the lines of a violation of constitutional rights. Fifty-nine voluntary organisations filed this in the High Court.

These efforts were not in vain, as of 14th March 2000, the High Court declared the eviction of brothers and the detainment of sex workers in "rehabilitation centres" unlawful. The verdict itself ordered the immediate release of sex workers in these centres and order never to evict brothels without a respectful and well-crafted rehabilitation plan. Not prison-like conditions.

It is profoundly encouraging to see that there were cases where the state and legal system were on the side of the outcast. It is essential to recognise that these women are not purely sex workers. These women have a personal history, personal responsibilities and all are human beings. The radical bridging between sex workers and the mainstream

women's movement led to a fight against state machinery. This strength led to a favourable, victorious verdict. The impossible can overcome when we take up arms together to do so.

THE BIRTH OF THE MODERN WOMAN

The push for equality in the workplace has had a longstanding history in our country. In the recent past, there has been a significant shift in attitudes towards women in paid employment. As there is increasing industrialisation and a need for labour, large numbers of women from landless and middle-class families need economic wealth. Both urban and rural women have embraced opportunities when they arise.

The very aspiration from Bangladeshi women is a masterpiece to behold. Societal and systematic barriers have hindered women in both rural and urban communities. The Bangladesh Enterprise Survey (2013) concluded "direct dissemination by employers and managers."[54] Thus, regarding women's presence as "potentially disruptive to the work environment." Therefore, there has been prevention in entering the workplace and building successful careers. There is a great need to "break the glass ceiling."

The notion of a "glass ceiling" indicates an invisible barrier that prevents women's career advancement. The transformation in male attitudes and the expansion of educational opportunities have helped bring change to female participation in employment. In Bangladesh, there has been a gradual positivity in girls' education. For instance, in 1993, the proportion of girls completing school grades was significantly less than boys. If we compare that to the 2010s, girls enrolled in education amounted to fifty per cent.[55]

An entire balance has been struck. Therefore, knowledge has contributed to the destruction of the "glass ceiling". We must continue in the steady decline of gender discrimination, allowing Bangladesh to rebalance the gender ratio in state education. The intrinsic empowerment shall have a domino effect in families developing interest in their daughter's financial independence and less discrimination. This shall cause a ripple effect in broader society.

Nevertheless, there are situations where a qualified woman's advancement may be halted due to sexist discrimination. For instance,

male preference still exists within the family, and patriarchal power manifests in other forms, such as family assets inheritance. The gender discrimination has created obstacles for women in access to public employment - both systematic and subjective. As a result, society must change to allow women to experience true financial abundance.

It is inspiring to see that the minds behind crafting the Constitution of Bangladesh were committed to breaking the glass ceiling, as it is reflected. In Article 10, it is written that "steps shall be taken to ensure the participation of women in all spheres of national life.", with the promise of the removal of "social and economic inequality between men and women." There is an explicit emphasis on the hope that "women shall have equal rights with men in all spheres of the State and public life." under Article 28(2). Therefore it is evident that there was a state effort for equality in the workplace, further demonstrated by creating the "Women's Rehabilitation Board" in 1972.

An admirable aspect of the Constitution is that it addresses issues on a national basis - it does not specifically cater to white-collar jobs or more respectable positions in society's eyes. The underlying messages of the Constitution have been amplified in the historical state initiatives. The Constitution itself promised the implementation of effective measures to ensure equality in the workplace. This can be seen through the quota system and affirmative actions to provide such a thing happens.

These measures dwell upon the state to ensure equality in governmental and non-government occupations. For instance, from the very beginning - there was an understanding that positive steps had to be taken to ensure equal workplace rights were fully embraced. Hence, the requirement for 10% in government and non-governmental jobs for women was established as far back as 1976. In the present day, the Constitution provides for a 300 member parliament. In the Constitution's initial age, 15 seats were reserved for women in 10 years

with both men and women eligible to contest for territorial constituencies.[56]

Employment within Bangladesh cannot be explored without mentioning the garment industry. There is a vast disparity for rural women within Bangladesh's labour force, as rural women have the highest unemployment rates. The expansion of manufacturing in low-income countries has allowed women to enter the labour market as garment workers. Through these financial opportunities, there has been a sharp increase in women's employment as women unable to break into traditional career markets can do so through the garment industry.

Nevertheless, critics believe that the cheap labour within the garment industry has led to severe labour exploitation. Despite the socio-economic achievements, gender discrimination and harassment have overshadowed these opportunities. Female workers are perceived as less valuable, less worthy of fair wages and treatment. The structures of male dominance are entrenched deep within the economy, as well as the home.

Please make no mistake; the Bangladeshi garment industry would not survive without its female workers. The women play a critical role in the industry, acting as the backbone of its labour force. The garment industry is one of the rare avenues for a Bangladeshi women's economic independence. There are many hindrances in Bangladesh's society that serve as a significant barrier to women's empowerment. For instance, young married women struggle much in attaining employment due to early child births.

The garment industry's birth allowed women to access exceptional ability to gain employment and achieve mobility in the public sphere. Women are challenging the status quo, as garment workers are heralded as the "heroines of the nation", but this is hypocritical because women are subject to exploitative practises. From unpaid overtime, harassment,

hazardous work environments to lack of maternity leave, the list is endless.

That does not mean to say garment workers take the exploitation lying down. There is a deep history of garment workers protesting for their rights. After the Rana Plaza collapse, fifty thousand workers demanded higher wages via street demonstrations[57]. Nevertheless, workers have been suppressed in fighting for their rights. In 2005, unions were prohibited from canvassing. The unfortunate truth is that many politicians are tied to the garment industry. Therefore reform is near-impossible. In January 2019 alone, fifty thousand garment workers dominated the streets of Dhaka for higher wages. As a consequence, five thousand garment workers were unfairly fired.[58]

Bangladeshi society is built on a foundation of structural violence. Societal norms have led to the oppression that allows for discrimination and injustice. If structural violence exists, members of society thrive and suffer under the same conditions. Their social and economic circumstances determine how society sees them. Therefore, *true* empowerment for women is not possible. If we allow the structural violence to stay in play, women shall not improve their conditions. How can they? Women do not earn a sufficient wage to cover living costs. On top of this, it is common to practise for women to be denied legal rights. Maternity leave is non-existent, as well as legal corrections. Therefore, the door is left open to all forms of harassment.

Women shall not have the confidence to fight for more economic autonomy. As we have witnessed, the greater independence a woman gains, the more violence is exerted upon her. As Bangladesh is deeply entrenched in patriarchal views, it may be an unconscious way to protect the status quo. Thus, restrictions stay in social and economic values. We cannot clap ourselves on the back for the so-called increase in women's employment if these are the conditions. It is not sufficient to have a "choice"; women must exercise choice through extensive resources. Not two or three avenues.

If we are to observe the positive, some avenues have provided tremendous impacts on women in Bangladesh. Namely, the rise of microfinance. Microfinance is a banking service catering to unemployed or low-income individuals. In the traditional world of finance, these individuals are unable to gain access. Microfinance loans are small loans to purchase resources necessary to establish an economic basis, for instance, for small business owners. Borrowers can pay these loan returns with minimal interest. Therefore, individuals are successful in creating stable economic opportunities.

Microfinance cannot be seen as the "one size fits all" solution for overcoming poverty and gender discrimination. Nevertheless, microfinancing has become a powerful income-generating resource for rural women. As a consequence, women can create enterprises to support households.

In 1976, Grameen Bank was launched on an experimental basis. By 1983, it had become an iconic institution as a unique credit agency for poor rural women in landless communities. It is now the Centrepoint for microfinancing loans. The initiative's purpose was to organise and assist women in enhancing their economic circumstances. At the end of March 1989, the Bank had established 571 branches with over half a million members. The Bank was home to a breathtaking 92% of women members, reaching over 11,000 villages[59].

These organisations were centred around empowerment and solidarity. Through the collective agenda, women developed a camaraderie and stood by one another. As economic conditions improved in their favour, they had the bravery to challenge society and have decisions made in their favour. Grameen Bank was awarded the Nobel Peace Prize; it claims that their female borrowers return to 98% of the original loan.

Microfinancing has been a catalyst in reducing women's vulnerabilities; it has placed women in a stronger position to negotiate

in the household and workplace. However, the number of initiatives similar to Grameen Bank is minimal.

Thorough research demonstrated that women who were successful with microfinance were socialised to bolster the resources. For instance, these women had been educated in establishing a business, economic budgeting and negotiations. For women who had no access to such training, their income fell prey to being used by the male figurehead solely. A striking number of cases illustrated husbands controlling the loans. Men became the beneficiaries of the microfinance loans, as women are not seen as the breadwinners. Men are assumed to be the sole provider of families.

As a consequence of patriarchal conditioning, men naturally fall into the role of control. Therefore, we cannot solely depend on microfinancing to be the solution. We must harmonise these efforts with educational, financial and community-orientated training.

In addition to this, we must not depend on independent community networks to do all the work. Women's advancement and equality can only be accomplished if the state and other development organisations collaborate with the collective mission in mind - upholding human rights.

In the public sphere, the small percentage of women in both government and non-governmental jobs were heavily criticised by Bangladesh Mahila Parishad because it was not seen as a significant effort for progression. This criticism is understandable, but this was likely seen as the best compromise to make both society and the women's movement happy at the same time. On a community level, Bangladesh has witnessed rapid changes in the lives of marginalised groups. Nevertheless, these changes have not transmuted to the higher levels of politics. Therefore, one can see where Bangladesh Mahila Parishad's criticism stems from.

One should question whether gender equality should be a compromise at all.

In the political sphere, there has been no increase in the quota percentage as far as we are aware. Therefore, the number admitted in the political sphere is relatively small. Bangladesh must evaluate its quota system, and improve the environment for all genders. The essence of percentages appears to be solely based on gender politics. This is demonstrated by the focus on "inner dynamics and policy outcomes" regarding gendered representation[60].

If the state assumption on gender equality is based on gender differences, the state cannot guarantee equal access to men and women's employment or rights. This is evident in women being unable to exert the power of the Bangladeshi society's economic structure. Thus, resulting in the minimal effort in the quota system to the failure of securing a Women's Development Policy that ensured a woman's equal right to property and inheritance in the current day.

These statistics demonstrate that despite a woman politicians' commitment, she will face inherent political risks when actively advocating women's rights. The desperate need for a quota system was due to women's inherent political weakness in opposing general seats, as the political system was primarily patriarchal in the beginning.

Studies found that "women are 25% more likely to speak at village meetings where the local political leader position is reserved for women."[61] As a consequence, a well-implemented quota system must be introduced. We must not only raise the voice of leaders but the voice of other women in the community. Nevertheless, it is no surprise that the quota system became stagnant in progress. Male politicians elected in territorial constituencies can often ostracise those female politicians.

The quota system itself cannot be permanent, and it needs to evolve according to the demand and the context. Indeed, the modern development of the quota system of one-fourth for women in local bodies being elected through direct elections demonstrates strong political will. However, this reserved seating's inherent contradiction is that women leaders have treated this quota system as a reservoir of

political power; rather than taking proactive measures to encourage women of all respective parties to fight and claim these seats. Thus, showing the country the expertise they uphold. Therefore, this approach has left the electoral field open to male domination and not accurate feminist representation.

The territorial attitude towards personal power can lead to in-fighting within feminist communities, thus encouraging public criticism of female presence within the political sphere. For instance, male politicians from selected territorial constituencies have belittled women in reserved seats. This is due to the notion that female politicians are seen as nominated, not as elected. Often, women who engage in politics can excel if they are successors of family members. Therefore, a newcomer with no political connections in the family can be restricted in their success.

The prejudice within the political field has devalued the strength women can bring to the table as it is not perceived as "real" representation. The apathetic attitude and gendered views determine feminist participation in politics. There is a severe restriction on a woman's sustenance in the political sphere. The naysayers of the quota system have failed to notice one simple fact - if the system were not so set in obstacles for women, there would be no need for quotas.

It is evident that, although the Constitution and the legal system is designed to give equal rights to women in all sectors, society and legislative measures are full of flawed internal contradictions. The quota system was intended to be a time-sensitive political measure for ensuring women representation in the legislature. However, merely adopting and implementing equal employment principles do not guarantee gender liberty.

These privileges cannot provide a genuine acceptance of women in the economic sphere. Therefore, the quota system should not be solely depended upon for eliminating discrimination in public employment. It is clear that if the state assumes equality based on gender differences,

there will be no guarantee of equal access to men and women's resources and rights. About a previous point, the Constitution was framed with predictions for the future.

The Constitution's minds believed that ten years would have been an adequate estimation for women to acquire the resources to enter the political sphere. That was an unfortunate miscalculation. The intentions of the constitution framers reflect the state's usual approach - the paternalistic approach. Therefore, the Constitution allows the visibility of female politicians but does not empower them. Realistically, a female politician can enjoy no hindrance in the political sphere through these main avenues; a familial tie to critical leadership or political prestige drew from crucial associated with a dominant political party.

In contrast to this restriction, male politicians need not demonstrate any political commitment to share the general seats or any direct linkage to constituencies. Male superiority must be eradicated, as it's ever-constant presence will hinder women from reaping the rewards of their hard-earned efforts. Male politicians must be active in contributing or reinforcing women's political strength.

The quota system can be successful; however, this depends on whether the legislation dictating such a policy provides equal provisions for both men and women. The need for reserved seats should not be underestimated, as the discourse around quotas moves beyond statistics on a page. It encourages commitment from executive bodies, who have a crucial influence in the nation's decision-making - both on a local and national level. This is key because quotas place powerful women in decision-making positions whereas, traditionally, women were seen as devoid of power. Thus, there is a change in the notion that women are poorly represented in economic decision making.

If we challenge traditional measures in the labour market, we cannot empower vulnerable women in our community. Traditionally,

female independence and sexuality are managed through early marriage and seclusion. Therefore, interactions between men and women are more controlled. The earlier the marriage, it is likelier for the woman's employment and education to be interrupted.

In the rare opportunity that a woman receives family support, the chances of attaining a highly-paid job are next to nothing. A young bride makes it easy to assimilate her into the responsibilities of housework and parenting. As a result, we cannot formulate a collaborative dynamic where both sides debate and compromise on concerning matters. This lays the door open to exploitation.

For instance, the increasing number of women in the garment industry has been attributed to the fact that young women have been more willing to work under exploitative terms[62].

Due to the lack of cooperation between men and women, young women have been mainly employed because there is more flexibility and a willingness to work at lower wages, which the average man may not even consider. The employment of young women in such labour-intensive industries is seen inspired by their weaker economic and social position. This is simply unacceptable.

If we allow women's wages to lower, they will continuously be seen as docile, and it shall lead to an intensification of gender inequality. Admittedly, there are benefits to women working in the garment industry, as some economic autonomy is earned. Nevertheless, the standard narrative within the garment industry seems to be that female workers are aware that there is an apparent disparity between women in the workplace. Still, there remains a submission to submit decision-making responsibility to the head of the household. The pressure to conform to traditional female behaviour still exists.

If we allow new socialisation to take hold, women will advance further. There shall be no constraints in the seeking autonomy. Nor will there be stigmatisation for determined, hard-working women. There will be a clear differentiation in status and earnings, meaning that

women shall foresee an advancement in their career. A camaraderie amongst women can exist, where we look out for one another and witness equal opportunities coming to the forefront.

If women in employment can negotiate within their households, some independence and autonomy resulting from their potential, gender disparity will be weakened. Homosociality dictates that men have "the tendency to prefer men for self-reflection...and social support"[63]; therefore, there is a deeper hold on outdated cultural norms. Cultural norms have preserved financial autonomy as "man's work", our traditional culture deprives women of the steadfast self-esteem necessary for leadership in the world.

We must integrate women into economic independence, as it will create shifts in society and allow women to discover their potential. We must have confidence in our power to challenge social norms to reach heights in the community. The strongest opponent is "patriarchal apathy towards women's claim to power"[64]. We must defeat this apathy if we transform the political sphere from a prejudiced atmosphere to an unbiased atmosphere.

THE REBIRTH

There is real beauty in being Bangladeshi. The foundation of our existence is rooted in liberation and freedom. There was a dramatic surge of public spirit, with every civilian wishing to play a crucial part in creating a new nation. We manifest great pride in people power.

The importance of freedom displaying from the people has been a long-standing presence in philosophy and history. Throughout history, the advancement of civilisation has been closely tied to the ideal vision. The perfect perception that all rights are universal, with entitlement to freedom, dignity and security. Foucault saw power as stemming from below. The state is not the source of energy, but the civilians. There was no such thing as state power solely by itself, but strategies originating from situations in a particular society.

That is why, it is genuinely heartbreaking, that feminism has taken a step back in its ferocity and light. It is rare for a country to begin its history with such radicalism and free spirit, yet here we are.

Nevertheless, somewhere along the way - the fire in our hearts was extinguished.

The heart and soul of society is dependent upon how human rights are recognised. It is easy to reduce non-western women as "poor, uneducated and weak victims", rather than celebrating the diversity and complexity of non-western women. The women's movement understood this and championed tirelessly to make it so. The togetherness in the women's campaign appears to have dissipated. In the past, civil society was decisive in bringing the attention of human rights transgressions, placing importance on oppressive measures' accountability.

The women's movement fought relentlessly against the stereotypes of women being weak and passive. This inferior status restricts their rights, pressuring them to remain within domesticated roles rather than pursuing progressive careers and breaking down society's barriers.

Therefore, it is our responsibility to shoulder our ancestors' burdens, who paved the way for the opportunities that lay before us today.

There is a need for a "democratic revolution" in the negative perception in feminist agenda. Social and economic policies directed towards women remain inadequate in resolving problems because they reflect the male perception. It is all well to say that the state's actions have recognised women's rights, for instance, through the Constitution or the quota system within the political sphere. However, a recognised right is not always an executed right, as demonstrated by the shortcomings of inequality within education, the workplace and the private household. Thus, leading to a deeper divide between the two genders.

We must demand a broadening of provisions in improving the welfare of women. We have to rise up and above because tomorrow is on the way - let us lead it in the right direction.

A way to do so is education. Bangladesh is profoundly dedicated to gender equality in education. Primary school education is critical for every child; it allows for a thirst for knowledge - a more significant curiosity to what the world can offer. As a result, primary school education has equipped Bangladeshi girls with the necessary life expertise to apply to their day-to-day challenges. For instance, primary school education gives children the ability to read and write essential texts, as well as being able to calculate simple arithmetics. The state stipend programmes shall encourage families to further their daughter's education. As more women become first graduates in their families, it shall create a more open dialogue on women being decision-makers in their *own* lives.

Nevertheless, constraints remain in higher education as subjects are stereotypically programmed with women being directed towards humanities subjects over business subjects. On top of this, there is little investment in further career development. There must be

improvements in women's opportunities in building their technical abilities, so there is a chance to aspire to higher-paying industries.

We often see education as a god-given right, which should be. However, it is easy to forget that not every citizen has equal opportunities. Therefore, if we are to advance as a country, every part of the system must work together. If true gender equality is to be achieved, more work is needed to solidify the quality in higher education. Women with higher education face higher unemployment over their male counterparts[65]. Therefore, we cannot pride ourselves in achieving gender parity in primary and secondary education alone. If women are hindered at the first hurdle of education, Bangladesh will remain stuck in its problems.

It makes one hope to see the commitment to more excellent gender representation in the workplace. We have achieved more significant streamlining of women into development organisations, and there appears to a gender perspective on every project. Gender equality determines development.

Therefore, representation allows us to recognise failings within the system and addresses these failings. In the modern workplace, Bangladeshi women consistently face threats, intimidation and abuse. Physical and sexual. Authorities must do more to protect labour rights.

Women's rights have declined precipitously, and union organisers are not able to protect the vulnerable ones. There is a severe pressure that hinders their freedom to organise and demonstrate. Therefore, women are laid bare and susceptible to all forms of abuse; verbal, physical and sexual. If Bangladesh wishes to prosper, it must create a safe work environment for all women. Therefore, the authorities must stay committed to ridding it of sexual violence.

Workplace violence is most prevalent in the garment industry. Bangladesh relies heavily on the garment industry, responsible for 80% of its exports and roughly four million jobs[66]. The ongoing intimidation towards union leaders results in an inability to investigate

abuse claims. The majority of union leaders are female workers, who make up most of the Bangladeshi garment workforce. The garment industry has been transformative for all women. It allows freedom for financial abundance and independence.

Nevertheless, it is believed that only one in three Bangladeshi women are employed. Women experience poverty more intensely than men. If a household abides by traditional rules, the women must stay home and care for the children even though she may not have the resources to do so. In leadership roles, only one in ten are successful in achieving such a position[67]. Besides, the availability of facilities does not correlate with the demand. There is a severe lack of day-care centres for young children, therefore hindering women from pursuing a working career.

The scarcity of resources in Bangladesh leads to unstable households and the frequency of divorce increasing amongst poor and landless groups. There is now a greater tendency to leave marriages, thus abdicating any financial responsibility towards the families. Therefore, the need to balance work and family duties must be considered, as our society habitually depends on women to raise the children.

Speaking of facilities, Bangladesh must work harder to ensure the physical safety of women. The government figures estimate that there are 320 maternal deaths per 100,00 live childbirths. However, the United Nations estimates the rate to be much higher, with 570 deaths per 100,000 births. The likelihood of a Bangladeshi woman dying in childbirth is 1 in 51 with a rough estimate of 12,000 women dying every year from pregnancy or medical complications[68]. The majority of childbirth deaths are premature girls. For a child to be married before eighteen, it is internationally deemed a "violation of children's rights". However, this notion is envisaged in many cultures.

We must continue to lower child marriage rates and fully address the barriers to girls' educational opportunities. It has been repeatedly

reported that child marriage is linked to a denial of other fundamental rights. Examples to come to mind are the right to education, protection against discrimination, and the deprivation of physical and mental development. Bangladesh must commit to keeping girls in school by supporting their endeavours.

As child marriages are rife in Bangladesh, it has led to the country having the highest rates of adolescent motherhood, with 1 in 3 women childbearing before the age of 20[69]. There has been a reduction in teenage births; however, the pace of decline is languid, and it remains common in rural communities. By continuing child marriages, the state puts young girls in the firing line for physical and psychological abuse.

Young motherhood is associated with several risks, such as higher maternal mortality rates with pregnancy complications resulting in low birthweight babies. The threat of adolescent motherhood is primarily due to patriarchal norms and structures. There is a real stigma against contraception; therefore, there is a practical exposure to premature pregnancy and sexually transmitted infections. There appears to be a lack of freedom to seek medical assistance as underage marriages tend to lead to husbands or husbands' families, making decisions about their health care.

We must call for an honest social debate, bringing together community members for social change and providing alternative measures for early marriage as society's strength is not secured through good intentions but consistent strategic investments. In turn, this shall improve community maternal health practises and increase usage.

It is vital that there is a strong emphasis on the poor and socially excluded — for instance, women ostracised by society due to rape or other forms of sexual assault. There are community-based models in place for strengthening these practices. In the current day, these models have been piloted in select sub-districts of Chittagong Hill Tracts. Social change is not achieved through persuasive rhetoric but actions.

The centre point of these discussions must be protecting Bangladeshi women as one of the greatest tragedies is the increase in violence against our women. The number of rape cases within Bangladesh has increased drastically.

If it had not been for the women's movement in Bangladesh, sexual harassment would never have been a current issue. The concept of a woman living in a dignified environment would never have been brought to the forefront. There is now a consensus amongst the population that sexual harassment is a real problem.

Ain o Salish Kendra reported that between January - December 2018, 97 out of the 116 women surveyed were assaulted by stalkers throughout Bangladesh[70]. The number surveyed is small to imagine a higher number of women assaulted on a nationwide basis. Therefore, we must create a safe space where women can come forward and speak about sexual harassment. Women must feel safe to raise their voices against harassment and rape culture so that all are encouraged to take a public stance against sexism. If we do not address the catastrophic high rates of sexual harassment and create a harmonic dialogue between all genders, the future looks very bleak.

The need is so natural that the Bangladeshi courts have ordered the state to act. We witnessed this in 2009 when the High Court issued an 11-point directive on sexual harassment after a petition filed by the Bangladesh National Women Lawyers' Association (BNWLA). However, it was heartbreaking to discover that organisations have deliberately ignored these directives[71]. Again, the lack of strict implementation is failing Bangladeshi women.

Nevertheless, in the present day, the human rights organisation, Ain o Salish Kendra estimates that the number of rapes has doubled to over 1,500 within the last year. The fact that human rights organisations can deduce this information, but not official state bodies is shambolic. Ain o Salish Kendra was only able to record the statistics

through media reports and its victims coming forward. Therefore, it is logical to conclude - the number of rape cases is much higher in reality.

The danger of an ever-present problem is the possibility of desensitisation to the crime. There is a failure to implement a system where perpetrators are tried for such crimes. In the present day, there is a culture of impunity when it comes to violence against women. The exact magnitude of abuse is hidden because stigma and fear are present. Victims are terrified of telling their stories, as the fear of being ostracised is very real.

Women suffer in isolation, so they have no option, but to repress the bitter memories. As past chapters have proven, there is a severe lack of trust in the authorities. All these factors have led to social tolerance; therefore, an under-reporting of violence will always threaten our policing of gendered violence.

We must prevent people from becoming indifferent to this behaviour and believing it to be an impossible mission to accomplish. These adversities are a violation of rights, paving the way for cruel betrayals of a better life. Therefore, it is incredibly essential to sensitise the Bangladeshi community on the consequences of these crimes — namely, acid attacks. As there is a culture surrounding violence, this shall prevent future attacks and assist with reintegrating acid survivors into society.

Victims are often stigmatised by their attacks, which is a cruel norm that must be destroyed imminently. Therefore, there must be calls for national and local actions to promote rights and prevent violence. Society must advocate for a shift away from perceiving abuse as a series of episodes; there must be a recognition that power is a thread running through women's everyday lives everywhere.

In addition to this, there must be a vast support network for female victims. In relevance to health practices, it would be ideal for an increase in psychosocial services for survivors. For instance, this may be through establishing community-based mechanisms. Thus, a support

network would have a strong presence in the victim's community, and it would be instrumental in mobilising the reformation of social stigmatisation against victims.

This violence towards women extends to sexual exploitation, especially female children and adolescents. A rapid assessment found that over 600 children and adolescents had been sexually exploited, with a substantial increase in the number of trafficked women and children.[72] In 2019 alone, 4000 Bangladeshi victims of trafficking were found in rehabilitation centres. Out of the 400, 52% of victims were underaged. These child victims had been sold into trafficking by either their husbands or a third party[73].

All evidence demonstrates that the end of violence is a priority in achieving actual human development.

The evidence demonstrates that feminist organisations are needed more than ever. Women must be able to participate in matters affecting their own lives, thus establishing roles in shaping their future. There is extreme importance in establishing gender boundaries in all organisations, and there must be consistency in gender policies going forward.

Due to the country's political instability, non-governmental organisations save grace in maintaining pressure to prohibit misogynistic regimes. Namely, preventing dowries, enforcing minimum ages of marriage, effectively redistributing wealth equitably and enforcing an independent judicial system. To counteract the danger of civil liberties being threatened, there needs to be a vital representation in crucial state functions, and this extends to all state powers - legislative, executive and judicial.

The harmful cultural practises are discriminating. The acts are committed regularly over a prolonged length of time. Thus, communities and societies have deemed transgressions of humans rights as acceptable. Whether it be child marriage or acid attacks, all forms of violence against women have robbed us of our future.

Therefore, the state must be committed to increasing public knowledge as well as engaging politically. We have witnessed a consistent failing in implemental critical laws in protecting women. Therefore, there must be an active development and support in the implementation of rules and policies.

It should not be the sole responsibility of NGOs to provide aid to community-based programmes in empowering vulnerable women. Grassroots organisations have played a vital role in empowerment. These programmes allow women to achieve a degree of power in decision-making, and as a result, women feel more confident in facing resistance. Through education, women understand self-sufficiency and psychological resilience in the face of discrimination.

The programmes create camaraderie between women; thus, moral and emotional support is cultivated. NGO and state programmes create an incentive for women to stay within a school; these opportunities can be elevated through financial means. For instance, financial scholarships would lift the burden of debt incurred within education. These initiatives need help from all aspects of society, as they seek to transform harmful social norms. Therefore community-based programmes have the critical support they require.

As a consequence, this entails an increase in access to prevention, protection and care services. In addition to this, there must be an increase in state ownership over relevant programmes. In doing all of this, there will be true empowerment of women, who will express opinions on their rights.

From the very beginning, the voices of the women's movement achieved monumental success in our laws and policies. Women have defied social ideologies, the traditional power structure, and despite the shaming, they have established a life of independence. Thus, placing women at the heart of the action. Nevertheless, implementation has shown to be an issue still.

We tend to focus on the economic emancipation of women, but it goes deeper than that. The liberation of women goes further into the contributions of ordinary women towards the global development of Bangladesh. Not merely with the economy, but the cultural and social shifts that have allowed us into a more liberal way of living. We live in a paradoxical time, the country was acclaimed for gender equality by the World Economic Forum, but the patriarchy poisons us every day. Women may be contributing to the national economy, but we still live in a male-dominated social structure.

Change begins with us. The greatest obstacle is the justice system. There is a necessary need to review all discriminatory laws with gender development in mind. There is a conflict between state and society, but real change must come from within the system. Civil society and the state must come together to analyse how we may move forward constructively.

We must create new ways of tackling these challenges, as we have not yet overcome the patriarchal agenda. We have a responsibility to put equality and rights are the heart of our policies, so that all may benefit. It is not only a moral imperative to commit, but by empowering all women - it gives rise to a reasonable opportunity to accelerate Bangladeshi development in all spheres of life; moral, economic and humanitarian. Let us better this country, so that we may promote peace and opportunity for every Bangladeshi person. Let us be proud of a new Bangladesh.

To every woman in my life, this is for you.

Dear reader,

I have *always* wanted to say that in a book.

Thank you for reading *We Are Heroines*; as I write this letter, there is a bittersweet feeling setting in.

You see, I have been writing this book for three years. It has been by my side through the hardest and brightest moments of my life. When life became heartbreakingly difficult, it held me together as I remembered what the effort was all for.

We Are Heroines was inspired by the first article I ever published. If you have ever read *Take On The World*, you will be aware of *The Heroines of Our Liberation*. This piece celebrated the forgotten Bangladeshi women of the Liberation War and paid tribute to Operation Searchlight survivors. When I first came across the research, I was shocked to see that these historical testimonies were lost and ignored by the general public.

I would spend hours researching, researching and *researching* to no avail. There is the material out there, but it was scattered, and if you had no clue where to look, you would have no success. You may have noticed that I have used several resources repeatedly because it was difficult to find variety. So, I realized a need to create one resource where Bangladeshi women's history could be collated so that open-minded people could learn together.

I sincerely hope that your minds & hearts were opened to the women's movement, and I hope you recognize there is much work to be done. This book changed me. I went from a "black and white" viewpoint to acknowledging many nuances in the women's movement. No story is the same, and we have to adhere to that. Rather than believe our personal way is the right way. I have grown with this book, and I will always cherish it.

It is also the last book of mine for the foreseeable future. That is not to say I will *never* write a book again, but I never believed in doing something for the sake of it. The book was an absolute joy to write because I was connected to it. In a way, the book led the way. Not the other way around. Therefore, I will not be churning out books for no reason. I'm ready to start a new chapter (pun intended).

I want to turn your attention to a cause close to my heart.

The Mai Soli Foundation.

It is a non-profit organization working to change gender inequality in developing countries, focusing initially on Bangladesh.

I am vehemently against child marriages, as you well know. Mai Soli explores the core of why girls are often forced into child marriages., thus robbing them of freedom & agency. We want to challenge the patriarchal power dynamic, so women can be leaders on their own terms.

I am proud to have joined the Mai Soli Family as their Content & Community Coordinator. We work to elevate young girls by investing in their education, creativity, and potential. Throughout this book, I have advocated for grassroots and community-supported programmes. Mai Soli Foundation is an incredible example of doing so. If we empower our communities to create maximum impact, we shall create a strong foundation for women being invaluable assets for true freedom. Their confidence shall be unwavering and their mental strength unbreakable. Let us all work together to break the glass ceiling.

As I embark on this new journey with Mai Soli, I ask you to take part in our mission and ensure that all girls are never alone.

From the bottom of my heart, thank you for reading *We Are Heroines*, and I cannot wait to see where life will take us next.

Lots of love,

SEJUTI

[1] Chowdhury, F.D., 2004. Problems of women's political participation in Bangladesh: an empirical study.

[2] Alston M, 2015. Women and Climate Change in Bangladesh.

[3] Ibid

[4] Afza, S.R. and Newaz, M.K., 2008. Factors determining the presence of glass ceiling and influencing women career advancement in Bangladesh.

[5] Hashemi, S.M., Schuler, S.R. and Riley, A.P., 1996. Rural credit programs and women's empowerment in Bangladesh. *World development*, *24*(4), pp.635-653.

[6] Rodriguez, A.B., 2017. Women in the Workplace: The Impact of Earning Potential Empowerment and the Work-Life Balance.

[7] Karmojibi Nari.org. [online] Available at: <https://www.karmojibinari.org

[8] Sultana, A., Patriarchy and Women's Subordination: A Theoretical Analysis.

[9] Millett, K., 1969. *Sexual Politics*. Adelaide: Radical Education Project.

[10] Barrett, M. and McIntosh, M., 1979. Christine Delphy: towards a materialist feminism?. *Feminist Review*, *1*(1), pp.95-106.

[11] Human Rights Watch, *"I Sleep in My Own Deathbed"*. [online] Available at: <https://www.hrw.org/report/2020/10/29/i-sleep-my-own-deathbed/violence-against-women-and-girls-bangladesh-barriers>

[12] Unicef.org. [online] Available at: <https://www.unicef.org/media/files/Child_Marriage_Report_7_17_LR..pdf>

[13] Plan International. 2021. *How we stopped 2,000 child marriages in Bangladesh*. [online] Available at: <https://plan-international.org/blog/2016/11/how-we-stopped-2000-child-marriages-bangladesh>

[14] Human Rights Watch. 2021. *"I Sleep in My Own Deathbed"*. [online] Available at: <https://www.hrw.org/report/2020/10/29/i-sleep-my-own-deathbed/violence-against-women-and-girls-bangladesh-barriers>

[15] Islam, M.M., Islam, M.K., Hasan, M.S. and Hossain, M.B., 2017. Adolescent motherhood in Bangladesh: Trends and determinants. *PloS one*, *12*(11), p.e0188294.

[16] Czerniakowski, M., 2019. Rape Culture Reborn: A Posthuman Perspective on Rape in Westworld. *Roczniki Humanistyczne*, 67(11)

[17] Human Rights Watch. n.d. *Bangladesh: Girls Damaged by Child Marriage*. [online] Available at: <https://www.hrw.org/news/2015/06/09/bangladesh-girls-damaged-child-marriage>

[18] Dichter, T. W. (1999) 'Globalization and Its Effects on NGOs: Efflorescence or a Blurring of Roles and Relevance?', Nonprofit and Voluntary Sector Quarterly, 28(1_suppl), pp. 38–58. doi: 10.1177/089976499773746429.

[19] Ibid

[20] Ibid

[21] Schuler, S.R., Lenzi, R., Nazneen, S. and Bates, L.M., 2013. Perceived decline in intimate partner violence against women in Bangladesh: Qualitative evidence. *Studies in family planning*, *44*(3), pp.243-257.

[22] Yancey, T., 2015. The Multidimensionality of schoolgirl dropouts in rural Bangladesh.

[23] Sustainabledevelopment.un.org. n.d. [online] Available at: <https://sustainabledevelopment.un.org/content/documents/24797GSDR_report_2019.pdf>

[24] Stake, S., Ahmed, S., Tol, W. et al. Prevalence, associated factors, and disclosure of intimate partner violence among mothers in rural Bangladesh. J Health Popul Nutr 39, 14 (2020). https://doi.org/10.1186/s41043-020-00223-w

[25] Brownmiller, S., 1975. *Against Our Will*. Simon & Schuster.

[26] Ford, C., 2017. *Clementine Ford: Committing sexual assault is never 'out of character'*. [online] The Sydney Morning Herald. Available at:

<https://www.smh.com.au/lifestyle/clementine-ford-committing-sexual-assault-is-never-out-of-character-20170418-gvmz0q.html>

[27] Mookherjee, N., 2008. Gendered embodiments: mapping the body-politic of the raped woman and the nation in Bangladesh. *Feminist Review, 88*(1), pp.36-53.

[28] Nayanika Mookherjee (2016). *The Spectral Wound : Sexual violence, public memories, and the Bangladesh War of 1971.* New Delhi: Zubaan.

[29] Ibid

[30] Ibid

[31] Nayanika Mookherjee (2016). *The Spectral Wound : Sexual violence, public memories, and the Bangladesh War of 1971.* New Delhi: Zubaan.

[32] Nayanika Mookherjee (2016). *The Spectral Wound : Sexual violence, public memories, and the Bangladesh War of 1971.* New Delhi: Zubaan.

[33] Human Rights Watch. (2020). *"I Sleep in My Own Deathbed."* [online] Available at: https://www.hrw.org/report/2020/10/29/i-sleep-my-own-deathbed/violence-against-women-and-girls-bangladesh-barriers.

[34] The Economist. (1998). *Acid horrors.* [online] Available at: https://www.economist.com/asia/1998/01/15/acid-horrors?zid=317&ah=8a47fc455a44945580198768fad0fa41

[35] ActionAid UK. (n.d.). Acid attacks. [online] Available at: https://www.actionaid.org.uk/about-us/what-we-do/violence-against-women-and-girls/acid-attacks.

[36] White, S.C., 1999. NGOs, civil society, and the state in Bangladesh: The politics of representing the poor. *Development and change, 30*(2), pp.307-326.

[37] Ibid

[38] Elora Halim Chowdhury (2011). Transnationalism reversed : women organizing against gendered violence in Bangladesh. Albany: State University Of New York Press.

[39] Ibid

[40] www.aljazeera.com. (n.d.). Bangladesh police arrest man in connection with rape of student. [online] Available at: https://www.aljazeera.com/news/2020/1/8/bangladesh-police-arrest-man-in-connection-with-rape-of-student

[41] Basarudin, A. (2012). Transnationalism Reversed: Women Organizing Against Gendered Violence in Bangladesh. Gender & Development, 20(2),

[42] Chowdhury, F.D. (2009). Theorising Patriarchy: The Bangladesh Context. Asian Journal of Social Science, 37(4), pp.599–622.

[43] Rahman, M.S., 2018. Dowry, the Oppression of Women and Femicide in Bangladesh. Journal of Comparative Social Work, 13(1).

[44] Ibid

[45] Arends-Kuenning, Mary, and Sajeda Amin. "Women's Capabilities and the Right to Education in Bangladesh." International Journal of Politics, Culture, and Society 15, no. 1 (2001): 125-42. http://www.jstor.org/stable/20000178.

[46] Badri, A.Y., 2013. The role of the micro-credit system for empowering poor women. Developing Country Studies, 3(5), pp.2225-0565.

[47] Adams, P. (2018). Opinion | How Bangladesh Made Abortion Safer (Published 2018). The New York Times. [online] 28 Dec. Available at: https://www.nytimes.com/2018/12/28/opinion/rohingya-bangladesh-abortion.html

[48] Guttmacher Institute. (2016). Menstrual Regulation, Unsafe Abortion And Maternal Health in Bangladesh. [online] Available at: https://www.guttmacher.org/report/menstrual-regulation-unsafe-abortion-and-maternal-health-bangladesh

[49] Haddad, L.B. and Nour, N.M., 2009. Unsafe Abortion: Unnecessary Maternal Mortality. Rev Obstet Gynecol

[50] Nashid, T. and Olsson, P., 2007. Perceptions of Women about Menstrual Regulation Services: Qualitative Interviews from Selected Urban Areas of Dhaka. Journal of Health, Population and Nutrition, pp.392-398.

[51] Ibid

[52] WHO | Preventing unsafe abortion. (2014). Who.int. [online] Available at: https://www.who.int/reproductivehealth/topics/unsafe_abortion/hrpwork/en/.

[53] Sizear, M.M.I., Nababan, H.Y., Siddique, Md.K.B., Islam, S., Paul, S., Paul, A.K. and Ahmed, S.M. (2019). Perceptions of appropriate treatment among the informal allopathic providers: insights from a qualitative study in two peri-urban areas in Bangladesh. BMC Health Services Research, 19(1).

[54] World Bank (2015). Bangladesh - Enterprise Survey 2013. [online] microdata.worldbank.org. Available at: https://microdata.worldbank.org/index.php/catalog/1929

[55] Huq, M. and Rahman, P.M., 2008. Gender Disparities in Secondary Education in Bangladesh. International Education Studies, 1(2), pp.115-128.

[56] Chowdhury, Sahnawaj Mahmood, Reserved Seats for Women in the Parliament of Bangladesh - A Critical Analysis of Meaningful Representation (December 10, 2019).

[57] Rushe, D. and Safi, M. (2018). Rana Plaza, five years on: safety of workers hangs in balance in Bangladesh | Michael Safi and Dominic Rushe. [online] the Guardian. Available at: https://www.theguardian.com/global-development/2018/apr/24/bangladeshi-police-target-garment-workers-union-rana-plaza-five-years-on.

[58] Ibid

[59] Bangladesh Rio + 20: National Report on Sustainable Development 0 0. (2012). [online] Available at: https://sustainabledevelopment.un.org/content/documents/981bangladesh.pdf.

[60] The Implementation of Quotas: Asian Experiences Quota Workshops Report Series. (2002). [online] . Available at: https://www.idea.int/sites/default/files/publications/implementation-of-quotas-asian-experiences.pdf.

[61] Panday, P.K., 2008. Representation without participation: Quotas for women in Bangladesh. International Political Science Review, 29(4), pp.489-512.

[62] Women workers in the Bangladeshi garment sector. (n.d.). [online] . Available at: https://waronwant.org/sites/default/files/Stitched%20Up.pdf.

[63] Breines, I., Connell, R., Eide, I. and Unesco (2000). Male roles, masculinities and violence : a culture of peace perspective. Paris: Unesco.

[64] Fernandes, L. (2014). Routledge handbook of gender in South Asia. London ; New York: Routledge.

[65] Ahmed, R. and Hyndman-Rizk, N. (2020). Women's Empowerment through Higher Education: The Case of Bangladesh. International Perspectives on Gender and Higher Education, pp.213–230.

[66] Bain, M. and Avins, J. (2015). The thing that makes Bangladesh's garment industry such a huge success also makes it deadly. [online] Quartz. Available at: https://qz.com/389741/the-thing-that-makes-bangladeshs-garment-industry-such-a-huge-success-also-makes-it-deadly/.

[67] Salahuddin, Abu. (2011). Perceptions of Effective Leadership in Bangladesh Secondary Schools: Moving towards Distributed Leadership?. 10.13140/RG.2.1.1134.5760.

[68] Rahman, S.A., Parkhurst, J.O. and Normand, C., 2003. *Maternal Health Review, Bangladesh.* Policy Research Unit (PRU), Ministry of Health and Family Welfare, Government of People's Republic of Bangladesh, Health Systems Development Programme.

[69] Islam, M.M., Islam, M.K., Hasan, M.S. and Hossain, M.B., 2017. Adolescent motherhood in Bangladesh: Trends and determinants. *PloS one, 12*(11),

[70] Human Rights Watch. (2020). "I Sleep in My Own Deathbed." [online] Available at: https://www.hrw.org/report/2020/10/29/i-sleep-my-own-deathbed/ violence-against-women-and-girls-bangladesh-barriers.

[71] LII / Legal Information Institute. (2011). Writ Petition No. 8769 of 2010 BNWLA v. Govt. of Bangladesh. [online] Available at: https://www.law.cornell.edu/ women-and-justice/resource/ writ_petition_no_8769_of_2010_bnwla_v_govt_of_bangladesh.

[72] UNODC (2018). 2018 GLOBAL REPORT ON TRAFFICKING IN PERSONS. [online] . Available at: https://www.unodc.org/documents/ data-and-analysis/glotip/2018/GLOTiP_2018_BOOK_web_small.pdf.

[73] Ibid

Don't miss out!

Visit the website below and you can sign up to receive emails whenever Sejuti Mansur publishes a new book. There's no charge and no obligation.

https://books2read.com/r/B-A-PXSN-EHQMB

BOOKS 2 READ

Connecting independent readers to independent writers.

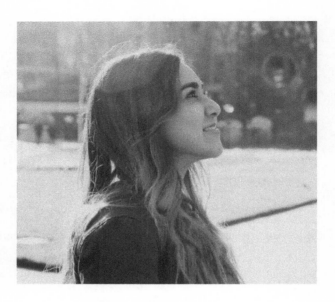

About the Author

Sejuti Mansur is an author and journalist specialising in women's, refugees and children's rights. In addition, you may have seen as her as the host of the Unfinished Memoirs. A program where she hosts young talents in thought-provoking conversations about the content in a creative space. A platform where young talents are not only elevated, but celebrated.

As her family heritage is held in Bangladesh, she focus upon issues within Bangladeshi societies.

She aims to be honest and progressive in her writing. As a young British-Bangladeshi, she grew up in a predominantly white community. Therefore, she understood the power in being different and embracing the "otherness" in her identity.

She hopes her books inspire you to question society. She hopes it inspires you to not be a bystander, but an active ally for humanity.

Read more at https://www.sejutimansur.co.uk/.

Lightning Source UK Ltd.
Milton Keynes UK
UKHW011959060922
408432UK00002B/339